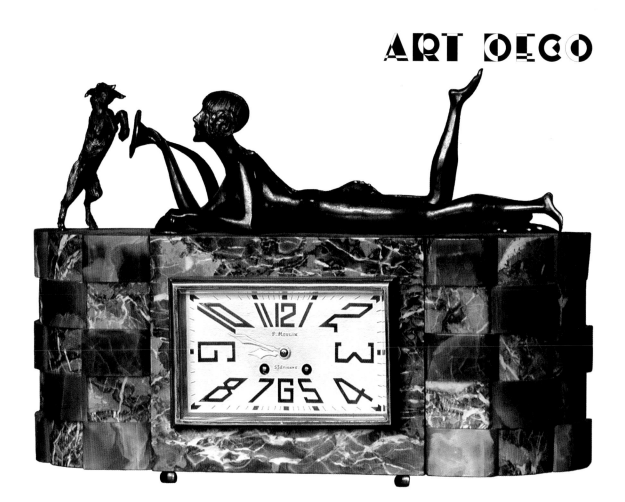

ART DECO

Endpapers: *the Chrysler Building, New York, 1928–29, by William Van Alen; these 77 floors of Manhattan Art Deco have a crowning peak that pierces the sky*

Previous page: *a typically Art Deco mantel clock by P Moulin of St Etienne, France, casually renders an insouciant female form in expensive materials*

Right: *detail of the back of a chair, designed by Clément Rousseau in the mid-1920s. The material used is shagreen (shark skin), with ivory inlays*

ART DECO

DEREK AVERY

CHAUCER PRESS

First published in Great Britain by
CHAUCER PRESS
an imprint of the
Caxton Publishing Group Ltd
20 Bloomsbury Street
London WC1B 3JH

ISBN 1 904449 09 3

A copy of the CIP data for this book is
available from the British Library upon request

Prepared and designed for
Chaucer Press
by Superlaunch Limited
PO Box 207
Abingdon OX13 6TA
Imagesetting by
International Graphic Services, Bath
Printed and bound in China

CONTENTS

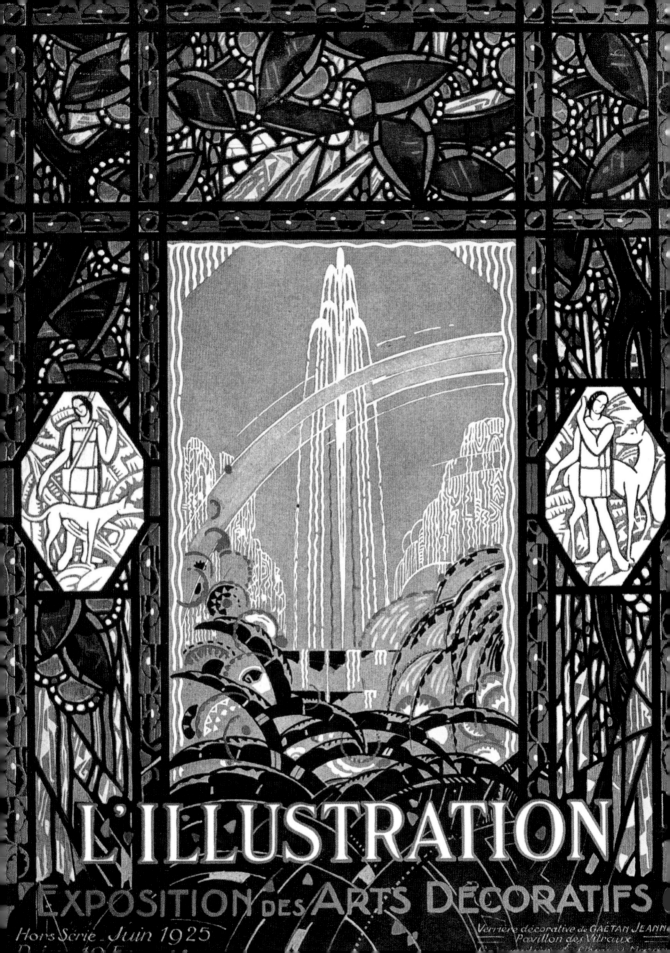

L'ILLUSTRATION

EXPOSITION DES ARTS DÉCORATIFS

Hors Série - Juin 1925

Verrière décorative de GAÉTAN JEANN...
Pavillon des Vitraux

INTRODUCTION

FOLLOWING THE LINGERING DEMISE OF ART NOUVEAU, the style which nowhere survived to any significant extent the outbreak of the First World War, Art Deco remained the most fashionable style of design and interior decoration both in mainland Europe and in the United States of America, until well into the 1930s.

The Deco style, with its characteristic geometric or stylized shapes rather than those of the equally decorative but organically-derived Nouveau, takes its name from the Exposition Internationale des Arts Décoratifs et Industriels Modernes, held in Paris in 1925.

Initially it was a luxury style which relied on costly materials such as ivory and jade but, especially later on, it also found expression in materials that could be easily and economically mass-produced, such as Bakelite and plastic. At least in part, this was a result of the lingering after-effects of the Depression.

The style developed rapidly, imposing itself and influencing the spheres of sculpture, metalwork, jewellery, and the graphic arts, as it evolved into a multifaceted style for all seasons and all tastes. Along the way it encompassed the gamut of scales from Manhattan skyscrapers to opulent Parisian furnishings, taking in such popular items as Bakelite radios, brightly-coloured Clarice Cliff pottery, and René Lalique glassware.

Left: the cover of the issue for June 1925 of the French L'Illustration magazine , in which the Exposition Internationale des Arts Décoratifs et Industriels Modernes was heralded and prominently featured. The centre of the cover shows René Lalique's glass fountain, while the geometric border features stylized plants

Art Deco was not merely a design style that was characterised by lavishly-decorated surfaces with vividly coloured geometric forms, stylized flowers, and lithe female and animal figures; it was *the* decorative style of the interwar years, invading all aspects of everyday life. Its seeds were sown long before the 1925 Paris Exposition, while its predecessor, Art Nouveau, was enjoying supreme popularity during the first decade of the twentieth century. Although it was then that the style originally developed in France, it was to be another decade before it was enthusiastically adopted in every western country, and it was not until the revival of the 1925 Exposition at the Musée des Arts Décoratifs in Paris in 1966, that the term Art Deco itself was first coined.

Following the complex Nouveau, Deco style was strikingly clean, pure and modern. Its lines did not swirl and eddy; their angular forms, stylized figures, linear decoration and modern simplicity suggested a cool, clear vision. Applied to everyday items, this bright boldness imparted a feeling of clean, uncluttered calm.

Yet Art Deco could not be termed a movement, for it had no founder, no manifesto and no philosophy. It evolved because designers and decorators, primarily those practising in Paris immediately following the end of the First World War, drew their inspiration from the demands being made by a restructured society.

As this style evolved, although its roots had been in the earliest years of the twentieth century, its clearest hallmark became a geometrical treatment largely derived from Cubism, in reaction to the earlier aesthetic. Everything from flora and fauna to the human form became angular, as the simpler, bolder new language developed a vocabulary of elements from the square, circle, triangle and cone. It neither was nor could be ideally suited to every form, but naturally those subjects that responded best to the Deco treatment featured most frequently, and became the style's icons. Initially these motifs included the ziggurat, the sunburst and the formalised fountain, while later on ideas such as streamlining and the syncopation of jazz appeared.

Below: *this deftly stylized reproduction of a stepped skyscraper typifies the iconic Art Deco motif of the ziggurat, in a grille covering for a heating radiator in the Chanin Building, New York, 1927, by Jacques Delamarre*

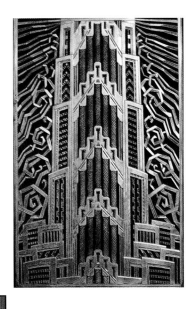

Left: *the Musée d'Art et d'Industrie de Roubaix occupies La Piscine, the town's original swimming pool, 23 rue de l'Espérance. This Art Deco building has an immense sunburst window at one end, seen here with its reflection in the water feature of the new museum. The old pleasure garden area was designed by the Lille architect Albert Baert (1863–1951), on the plan of a Cistercian abbey. The museum was recently converted by Jean-Paul Philipan into a glorious resource that depicts the life of the local economy through its fashion and textile industries*

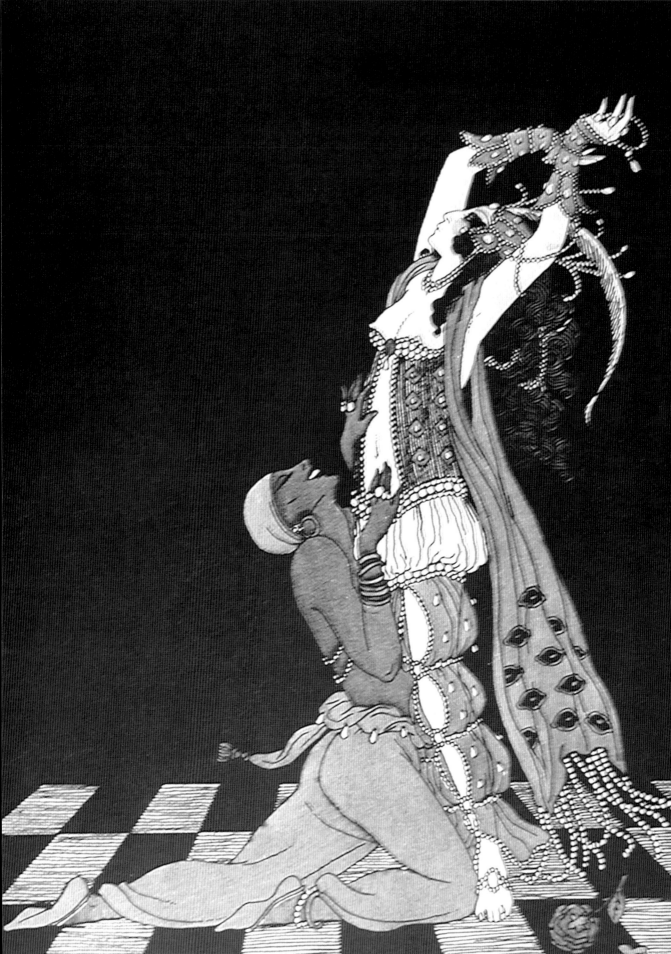

DECO ORIGINS

THE STYLE, WHICH IS GENERALLY CONSIDERED to have flourished between the two world wars, was not to be acknowledged as a separate movement until the 1925 Paris Exposition. This event acted as a showcase, both to become Deco's defining moment of triumph, and to bring to the fore many new designers and interior decorators.

It could be argued that the last decade of the nineteenth century had initiated the social freedom that eventually came to full flower in what in the UK we now know as 'the roaring twenties', and which in France is more dramatically termed *les années folles*. Following some half-century of Victorian social propriety and reforms, perhaps the civilised Western world had been ripe for revolution, longing to break out of its moral straightjacket to steal a sidelong glance at what had been conventionally kept hidden.

One such provocateur operating ostensibly within the established order was the Irish writer Oscar Wilde (1854–1900), a leading member of the 'art for art's sake' movement. The wit and irony of his plays are still appreciated today. The text for his *Salomé* was illustrated by the sensational black and white drawings in the highly individualistic asymmetrical style of Aubrey Beardsley (1872–98), whose work for the Yellow Book is still

Left: this drawing by George Barbier is very much in the style of Aubrey Beardsley's work. It is of Nijinsky performing in Sheherazade, *a ballet to music by Rimsky-Korsakov, which was based on the collection of stories known as* The Arabian Nights *and was first performed in 1889. In the early decades of the twentieth century, the precocious but short-lived Beardsley inspired artists everywhere who sought to liberate themselves from the imposition of tastes from the previous century*

Below: the Willow Tea Rooms, Glasgow, includes motifs the origins of which refer back to the ground-breaking black and white images of Aubrey Beardsley. They were designed by Charles Rennie Mackintosh between 1898 and 1904, and although the Scottish architect was dominant in the Art Nouveau period, examples of his work prefigured Art Deco not only in many of their decorative motifs, but also in the integrated style that he applied to every detail of the building

notorious. The pair became known as leaders of the Decadents of the 1890s; at this defining juncture, their work was reproduced in printed form and was widely available in all of the major cities of Europe and America, and their influence was immense as it was potent.

When Oscar Wilde's homosexuality became publicly known in 1895, the work of the duo could no longer regarded as merely provocative, that is, equating to the top shelf of the newsagent's shop today; in Victorian terms it was an evil from which polite society had to be shielded, and so now had to be banned.

However, the Victorian conservatives were too late; the oriental influence of the decorative motifs that punctuated and adorned Beardsley's work with such profusion had become part of the visual vocabulary and were destined to reappear repeatedly as they were reincarnated throughout the next 40 years as a means of expression for both Art Nouveau, and for the powerful style that followed, Art Deco.

Above: Deangate was transformed in an even more geometric style by Mackintosh, in 1916; for *instance, his wallpaper design, **left**, and **right**, the stepped surround of the fireplace*

Initially Beardsley's breakthrough in the freeing of imagery for expressive purposes gave the impulse to a group of artists who became known as the Glasgow Four. This group comprised the Macdonald sisters, Frances and Margaret (1865–1933), and their husbands, respectively Herbert McNair and Charles Rennie Mackintosh (1868–1928), its most famous member.

Charles Rennie Mackintosh's major achievement was as the architect of the new building of the Glasgow School of Art, won in competition in 1896. This building, on a clear rational plan with basic external forms equally clear and rational, is dominated by a completely original centrepiece of high fancifulness. Its large areas of blank surfaces, tall but sparingly-used windows, and highly stylized ornament, heralded from afar the coming of the Art Deco style. Furthermore, Mackintosh also assumed responsibility for the interior furnishings that included the furniture, lampshades, clocks, carpets, curtains and even the cutlery, to create a stylistic integrity throughout – an important feature of the Deco style.

Above: this lithograph poster, created c.1896 by Charles Rennie Mackintosh, displays both a laxity of discipline which might be natural in a draughtsman, and the compensating freedom and energy of a graphic artist. Even as early as this, he made use of motifs and strong straight lines, despite the overall Nouveau effect

Below: the Sezession exhibition building, Vienna, had a beautiful balance between its rectilinear elements and decorative details, and arguably was one of the most direct antecedents of Art Deco architecture

Another feature which alluded to the style of which the defining moment, the Paris Exposition, was still a quarter of a century away, was the strong rectilinear contours that Mackintosh used at the School of Art and even further developed some years later in his designs for Deangate, 1916. In this Northampton house the decorative style was completely abstract, comprising squares, chevrons and other geometric shapes.

In 1900 the Glasgow Four were invited to exhibit at

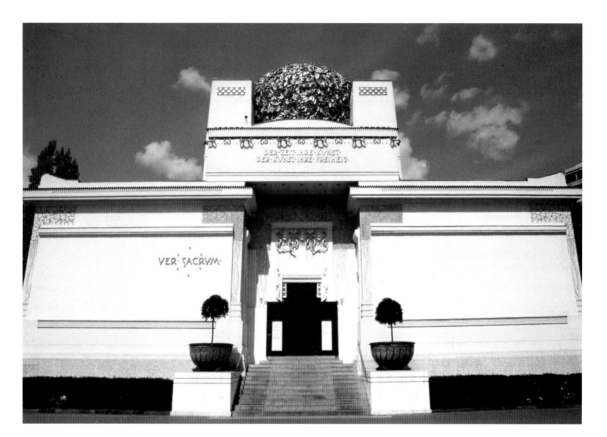

Facing page, top: the distinctive gilt cupola of the Sezession building and, **below** and **right,** examples of the external detailing that adorns the building

a show organised by the Vienna Sezession, where two of the founding members, Joseph Maria Olbrich and Josef Hoffmann, had been impressed by the geometrical simplicity that pervaded and characterised Mackintosh's work. These two Viennese architects were responsible for the two most fundamental examples of the Sezession's aesthetic. The Sezession exhibition

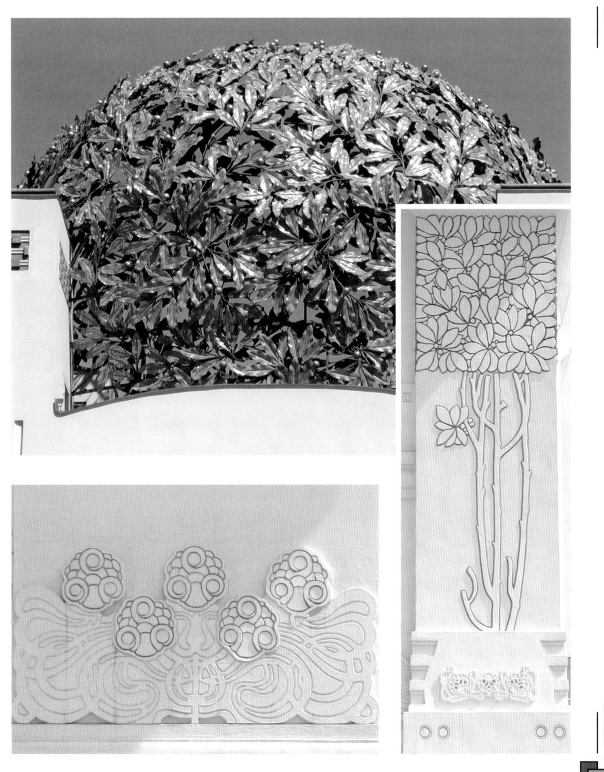

building itself, 1897–98, was designed by Olbrich. Its simple arrangement of cubic shapes is surmounted by a gilded sphere of wrought-iron laurel branches and it has small areas of stylized ornamentation, thus providing a clear expression of the ideals formulated by the Viennese artists. Hoffmann had actively promoted a more severe geometry in his designs, and now with the second signature piece, a silver-gilt tea-service of 1904, greatly anticipated the style of Art Deco.

The design outputs of the Vienna Sezession from 1903 were manufactured by the Wiener Werkstätte. Its most important commission before the First World War was the building and furnishing of Palais Stoclet, Brussels, 1905–11, for the Belgian industrialist Adolphe Stoclet. The building was designed by Hoffmann, but the detailed specification included the grounds and interiors, together with the furniture, textiles, lighting and cutlery.

Left: Palais Stoclet, Brussels, 1905–11, was designed by Josef Hoffmann, and was furnished by Hoffmann and other prominent designers of the Vienna Sezession and Wiener Werkstätte. This fifty-room mansion was built in Norwegian marble, with bronze framing. It showed some precursors of Art Deco features, including a stepped central tower, ornamental metalwork and prominent statuary. Adolf Stoclet, the owner, was the uncle of the French architect credited with designing the first Art Deco house in Paris, Robert Mallet-Stevens

Left: the Palais Stoclet's interior decoration was supervised by Hoffmann and realised by the Wiener Werkstätte, and included a hall, *left*, with an inlaid marble floor, palisander woodwork and deerskin-covered chairs

Below, left: the covered approach to the front door and *right*, the side entrance by way of the courtyard

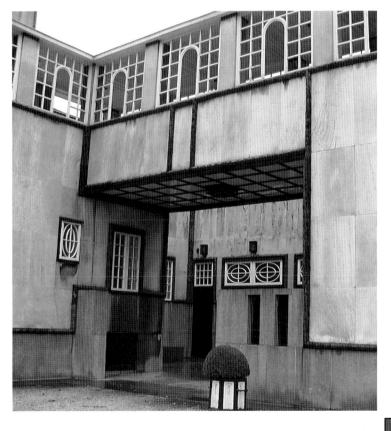

Above: the cover design by Peter Behrens for an edition of Deutsche Kunst und Dekoration, c.1900
Below: an armchair by Richard Riemerschmid, 1903

This brought together the work of the artist Gustav Klimt, who designed the mosaic murals for the dining room, with that of other members of the Werkstätte such as Kolomon Moser and Karl Otto Czeschka. Their creation, a supreme unity of design and luxury materials, was to become the precursor of many Art Deco schemes in the years to come. However, it was not only in Vienna that a new style was being formulated; across the western world from old Amsterdam to New Amsterdam (New York), pioneering designers were already striving towards the elegant simplicity that eventually would evolve to become Art Deco in all its jazz-age glory.

The simple geometry that was already gaining favour in competition to the sweeping arabesques of Art Nouveau can be seen combined with stylized and deliberately flat ornamentation in the work of a wide variety of Dutch craftsmen, such as the architect, Henrik Petrus Berlage (1856–1934); the potter, C J van der Hoef; and the silversmith, Jan Eissenlöffel. Across the Atlantic, the leading exponents included the architect, Frank Lloyd Wright, who was developing a style of domestic architecture devoid of historical reference, composed of geometric blocks. His contemporaries were re-clothing the American skyscraper, that hitherto had been easily bedecked with classical temple or gothic spire, but now began to wear an ornamentation that symbolised the dynamic of modern science and commerce.

Their work appeared at the same time as new techniques became available for the reproduction of photographs for printing, and so the spread of new design trends was faster and was given more immediate impact by the myriads of new magazines specialising in the the applied arts, such as *The Studio*; *Pan*; *Art et Décoration*; *L'Art Décoratif*; *Deutsche Kunst und Dekoration*; *Kunst und Kunsthandwerk*, and, not least, the Vienna Sezession's own magazine, *Ver Sacrum*.

Perhaps the most methodical approach to establishing a modern design aesthetic at the time was to be found in Germany. Here, industry was intent on finding a niche in the European market for all kinds of

household goods, and concluded that the obvious key to the solution was good design. Therefore a thorough investigative search for the right formula was instigated with the appointment of a civil servant, Hermann Muthesius, to outline the best route to follow. After exhaustive analysis, his recommendation was that Charles Rennie Mackintosh's Glasgow style would be the most appropriate for German industry to follow.

Coincidentally, at much the same time, the Grand Duke Ernst-Ludwig of Hesse had already become a convert to both the English Arts and Crafts style, and to contemporary English designs. In consequence, when he decided to establish an artists' colony at Matildenhöhe, Darmstadt, he chose as his leaders in the venture those designers whom he considered would best exploit the Mackintosh aesthetic.

Firstly the Grand Duke invited the Austrian architect and designer Joseph Maria Olbrich, a founding member of the Vienna Sezession, to design the most important buildings for his Artists Colony. Olbrich was joined in Darmstadt by Peter Behrens, the German painter and designer. The latter had been working in Munich in association with Richard Riemerschmid (1868–1957) and Alderbert Niemeyer, who had already improvised upon the work of the Belgian architect and designer Henry-Clément van der Velde. Van der Velde's own work in Berlin and Weimar was in an abstract variant style of Art Nouveau. By a further coincidence, it was at this time that Mackintosh's designs for the *House of a Connoisseur* were published in Darmstadt.

Behrens himself had become greatly influenced by Muthesius' investigations and conclusions. However, the civil servant proposed a closer working relationship between design and industry, a suggestion that was was very much at odds with the individualistic approach promoted by the Arts and Crafts ethos and the more Art Nouveau style designers such as van der Velde. Behrens anticipated that this would impose a degree of standardisation upon the manufacturers, and that ultimately this would give the German machine-

Below: the roof of the famous Wedding Tower, Mathildenhöhe, Darmstadt, 1907–08, retains some of the curving elements of Art Nouveau but the Tower's remarkable solidity shows how, by this time, Olbrich's simplification of his decorative style had already developed a restrained sophistication

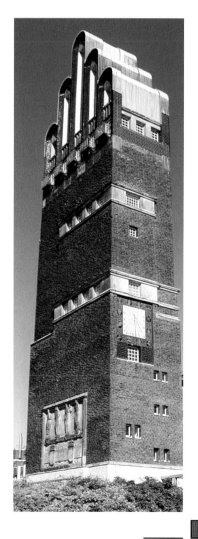

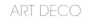

Above: bronze statues flank the entrance to the Ernst Ludwig Haus (now the exhibition centre), Mathildenhöhe, Darmstadt

Left: *Peter Behrens' own house, 17 Mathildenhöhe, 1901, shows the influence of Art Nouveau, with some curved windows and green tile decoration*

Below, left: *metalwork grilles over the windows on the Haus Dieters, on the Mathildenhöhe estate, bear a clear resemblence to those used by Charles Rennie Mackintosh for his Glasgow School of Art building,* **right**

Left: *these windows on the second floor of the Grosses Glückert Haus, Mathildenhöhe, show the decoration with motifs in a similar style to those that adorn Olbrich's Sezession exhibition building, Vienna*

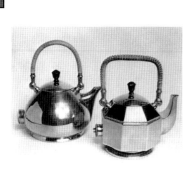

Above: kettles, designed by Behrens for AEG c.1908–10, show a lack of ornamentation and an insistence on functionality
Below: rue Franklin, Paris, 1902–03; Perret clearly expressed the reinforced concrete framing on the façade by the use of contrasting tiles

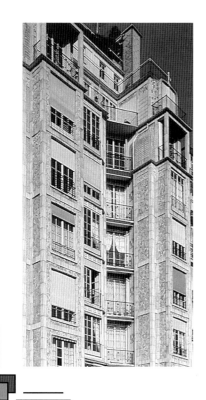

produced articles an individual identification. So it was that when he was appointed designer to the German Electrical Company AEG in 1907, he produced an entire catalogue of items derived from the neo-classicism of the early nineteenth-century architect K F Schinkel, whose unadorned work of the period contained something akin to a Georgian uniformity.

The year 1907 was an even more satisfactory year for Muthesius, who saw his doctrines achieve realisation with the formation of the Deutscher Werkbund. This was an association of manufacturers, craftsmen and designers, who worked together and to a high degree of standardisation, creating a neo-classical style. Their efforts received universal acclaim at the Werkbund's displays for the Paris Salon d'Automne in 1910.

The most fashionable of the *beau monde* in Paris were becoming a little blasé towards the Art Nouveau style by the start of the new century. This was marked in 1903 by the completion of the block of flats in rue Franklin by Auguste Perret. These already displayed the stricter arrangement and detailing of Mackintosh, before the dawning of the Deco style had become evident at the time of the 1910 exhibition. The building acted as an encouragement and a spur to other Parisian designers to seek more actively a new style. During the years that followed Perret's building, until the outbreak of the First World War, those such as Maurice Dufrène, Paul Follot and Léon-Albert Jallot sought out a new expression. René Lalique, who was more in the public eye, turned away from the creation of Art Nouveau jewellery and began to manufacture glass, particularly scent bottles. Lalique's work for the perfumier Coty was echoed by the coutourier Paul Poiret. His range of newly styled and packaged glass bottles was becoming so successful that he was able to open new offices in the centre of Paris in 1908, where he employed the services of Louis Süe, Raoul Dufy, Paul Iribe and George Lepape.

Poiret's timing could not have been more opportune, because in the following year Sergei Diaghilev and the *Ballets Russes* visited Paris, bringing

The organisation was founded in Munich in 1907 and was a labour league of artists, artisans and architects who designed mass-produced industrial, commercial and household products and furnishings, as well as architecture.

The architects Herman Muthesius and Henry van der Velde were the movement's intellectual leaders, and they took their influence from the English Arts and Crafts movement. Their aim, as a collaborative enterprise, was to revive industrial crafts as applied to machine-made goods. They were determined that form should be dictated only by function, and that unnecessary ornamentation should be eliminated.

Muthesius' ideals of standardised design and the maximum use of mechanical mass-production were adopted by the Werkbund in 1914, but the principles were not fully put into practice until the organisation was able to re-establish itself after the First World War. This it successfully did in 1927, with an exhibition in Stuttgart organised by Ludwig Mies van der Rohe. Here it displayed work by Walter Gropius and Le Corbusier, in addition to that of Mies van der Rohe, and all exhibits showed a high degree of standardisation of both materials and design.

The Werkbund also took part in the 1930 Paris Exposition organised by Gropius, László Moholy-Nagy, Marcel Breuer and Herbert Bayer. The organisation was disbanded in 1933 as the Nazi regime came to power in Germany

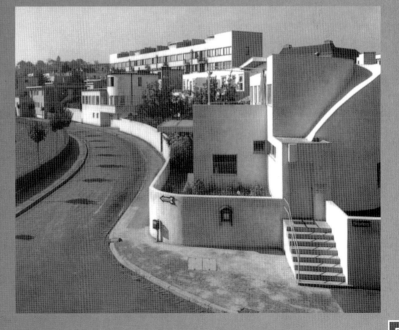

Right: there were 21 buildings at the heart of the Deutscher Werkbund Exhibition held in Stuttgart in 1927. This mixture of single-family dwellings and apartments was the work of 17 architects, and formed what was known as the Weißenhof Estate

with them their colourful exotic costumes and lavish scenery designed by Léon Bakst and Alexandre Benois. The 1910 Salon d'Automne and with it the Deutscher Werkbund's exhibition followed, providing more impetus.

Paul Poiret was so filled with enthusiasm by the events of these years that he embarked on an extensive European tour. This included Vienna, where he met the Werkstätte designers Dagobert Peche and Éduard Wimmer; Brussels, where he stayed at the recently-completed Palais Stoclet; Prague, which although now the capital of the Czech Republic was then part of the Austro-Hungarian Empire and was where he came into contact with Cubist-derived designs; Budapest; Moscow, where Poiret's own fashions inspired the young Erté, who years later would work on designs for Poiret in Paris but was then still known as Romain de Tirtoff; and finally Berlin, where the wealth of new ideas was a revelation to him and yet further encouragement for new experimentation.

Left: the Cubist-inspired Czechoslavakian architect and designer Josef Gocár designed this stained-oak sofa in 1913, its zigzag back indicating that the Deco style was on its way right across Europe

At the 1913 Salon d'Automne in Paris Jacques-Émile Ruhlmann exhibited furniture that was made from exotic woods, with inlays of ivory and ebony. These pieces were expertly crafted, they were elegant, they were new, they were ... Art Deco.

The style was born just as war was looming, but Ruhlmann's sensational artefacts had found the right combination to unlock the desires of an expectant and

anxious clientèle. His furniture was exactly what was needed, both by the new rich, and by those who were ready to kick over the remaining traces imposed by the Victorians from their moral pulpits. Then there was a war.

Above: René Lalique's scent bottles were some of the finest of the Art Deco period, and include those produced for Coty, which started a trend in both the design of the bottles and packaging

Above: this armchair, part of a suite in macassar ebony with ivory inlays, was one of the pieces of furniture displayed by Jacques-Émile Ruhlmann at the Salon d'Automne, Paris, 1913

SOCIÉTÉ DES ARTISTES DÉCORATEURS.

CATALOGUE DU Xme SALON 1919

RAPIN

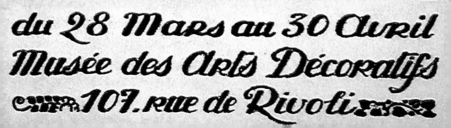

du 28 Mars au 30 Avril
Musée des Arts Décoratifs
107, rue de Rivoli

POSTWAR VALIDATION

THE GERMAN DECORATIVE ARTS EXHIBIT at the 1910 Salon d'Automne drew in everything in the room from carpets to the overhead lighting, a cohesive styling that made a deep impression upon the general public. Its French counterparts recognised the successful effects that this had enjoyed.

Thus, as soon as it was possible after the First World War, the officials in the Ministère des Beaux-Arts set out to promote the advantages of a unified style for the decorative arts. However, uppermost in their minds was the urgent need to kick-start the postwar economy, and with certain incentives available, both the artisans and the entrepreneurs were keen to make an early start.

So, as soon as 1919 Ruhlmann had set up a new company, Établissements Ruhlmann et Laurent, at 27 rue de Lisbonne, Paris; Louis Süe and André Mare together had founded the Compagnie des Arts Français; Edgar Brandt had established his metal workshops at Vierzon and René Lalique had set up a glassmaking factory in Alsace.

Also in 1919 the Salon d'Automne exhibitions were resumed, the first of which included an interior with and

Left: the cover for the 1919 catalogue of the Société des Artistes Décorateurs tenth Salon, which was designed by Henri Rapin, who went on to design many of the Sèvres Art Deco creations of the 1920s. After the war, the decorative arts exhibitions held in Paris had been quick to resume normal appearances

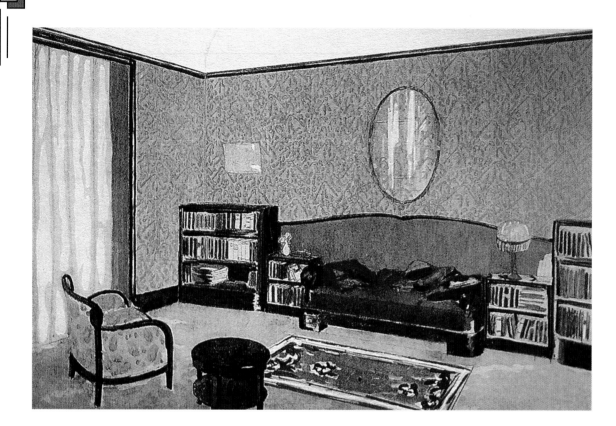

Above: *Louis Süe and André Mare began their association in 1919 with the foundation of the Compagnie des Arts Français, and published this design for a studio in 1924*

orange, black and gold-decorated walls by Atelier Martine. This was the company set up to produce furniture by Paul Poiret, following his return to Paris from his European tour. The work that it produced drew heavily from the encounters that he experienced on that tour.

All the prominent designers of the prewar period were active again by 1920, and the École de Paris was once more extremely popular as artists flocked back to Paris. From these swelling ranks both the manufacturers and the entrepreneurs of the French decorative arts could take their pick, and manifestly there were unrivalled opportunities available to young designers.

This atmosphere, and the versatility displayed by many among the emerging designers, had the effect of promoting the idea of a universal style which the Ministère des Beaux-Arts had promulgated. If a single style was to be adopted in postwar France its characteristics had to be established and promoted,

This Cubist-influenced Dutch movement was established in Leiden, the Netherlands, in 1917 and remained active until 1931. Among its influential members were the painters Piet Mondrian and Theo van Doesburg, and the architects Jacobus Johannes Pieter Oud and Gerrit Thomas Rietveld. They advocated a severe and precise economy of line and form, austerely pristine surfaces, and purity of colour. As a group, *de Stijl* influenced not only architecture but also painting and the decorative arts, including

Right: this façade for the Café de Unie was all of the Rotterdam building that was actually designed by the architect, Jacobus Johannes Pieter Oud. It equates to an architectural equivalent of a de Stijl painting, composed as it is of horizontal and vertical lines in the movement's colours of red, yellow and blue. In 1918 Oud had been appointed chief architect to the city of Rotterdam

furniture design, but the movement realised its stylistic aims mainly through architecture.

Oud's Workers' Housing Estate, Hoek van Holland, 1924–27, expresses the same clarity and order of line that is noticeable in Mondrian's paintings; as does the Schröder House, Utrecht, 1924, by

Rietveld, with its façade of severe purity.

The movement's 1926 manifesto was written by van Doesburg, and explains his aesthetic concept based on the use of inclined planes in geometric abstract paintings to increase the dynamic effect of the composition.

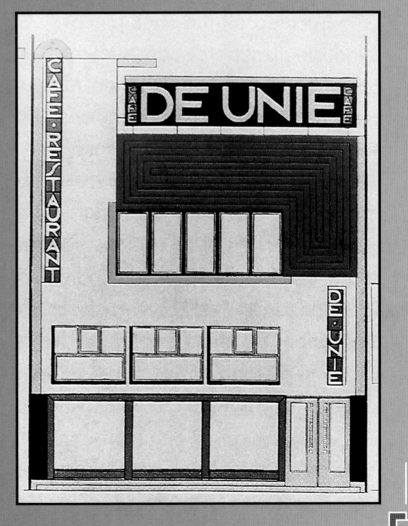

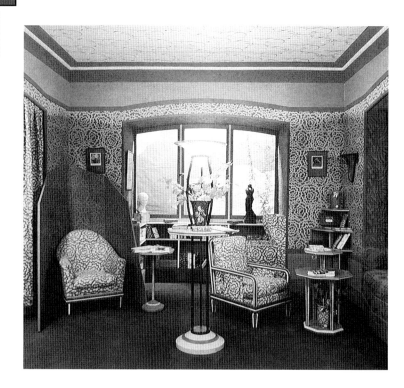

Left: an interior of silk-covered walls, screens and upholstery by René Herbst for the 1921 Salon d'Automne

and that opportunity arrived in 1925 with the exhibition of decorative art held in Paris, where French Art Deco was championed as the established style of the 1920s.

This newly-formed style, which had so many often unrelated and even contradictory manifestations, drew its inspiration from manifold and diverse sources. The best-known of these were African tribal art; the Aztec and Mayan architecture of Central America; and Pharaonic Egyptian art, Tutankhamen's tomb having been discovered in 1922. Also influential were the bold designs and bright colours of the *Ballets Russes*, the brilliant glazes and lacquerwork of the Far East, and the imagery and metalwork of classical Greece and Rome.

Other contributory factors were the forms of French furniture of the Louis XV and XVI periods, as well as such contemporaneous fine art movements as Fauvism, Constructivism and Cubism.

When the Deutscher Werkbund was formed in 1907, it had carried forward the logic of geometry that was at the heart of the Vienna Sezession and the Glasgow

Right: a pair of side chairs in ebony and stained tortoiseshell from 1924, by André Groult. They were painted by Marie Laurençin and were executed by Adolphe Chanaux

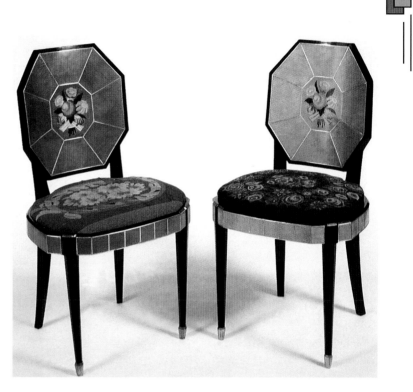

movements of some years earlier. The Werkbund put its emphasis on functional designs for mass production. Thus art was reconciled with industry, updated to accommodate the technological advances of the new century, and ornament cast into a secondary status.

These ideals were realised more fully with the formation of the Bauhaus in Germany, which in turn inspired the Modernist strain in American decorative art during the late 1920s. From 1923 the Bauhaus school began to develop design for industrial production, while at the same time its designs took on a more geometric appearance. At the same time the Modernists were also arguing that the new age required nothing less than excellent design for everyone, and that quality and mass-production were not mutually exclusive.

Although the objects and interiors displayed in Paris in 1925 were out of reach of the majority, the Art Deco style was a uniting style; it transcended social class, greatly aided by the increasing role of methods of mass production. Indeed, these were alluded to in many of

the new designs shown in Paris, and led to the greater availability of cheap consumables.

Art Deco invaded the entire range of disciplines, from architecture and furniture to industrial design. It embraced textiles, tapestries, rugs and carpets, fashion, book binding, the graphic arts such as typography, magazines, posters, and advertising, and touched the fields of lighting and the newly-arrived picture palaces. Glass, ceramics, silver jewellery and metalwork, painting and sculpture were all given the Deco treatment.

The style usurped the floral motifs of Art Nouveau which had adorned buildings and artefacts at the end of the nineteenth century, turning away from Nouveau's sensuous willowiness to instill qualities of purely abstract design and the use of colour for colour's sake, to deliver a neutral, no-nonsense simplicity to everyday objects.

Although Art Deco was an evolved style that neither began nor ended at any precise time, if it had not been for the abrupt four-year hiatus imposed by the First World War, most probably it would have run its full and natural course by 1920. As it was, it persisted and continued to develop until the mid-1920s, and its central tenets remained influential even on successive styles. Its demise, when it yielded to Modernism, began at the very moment of triumph: the Exposition Internationale des Arts Décoratifs et Industriels Modernes, Paris, 1925.

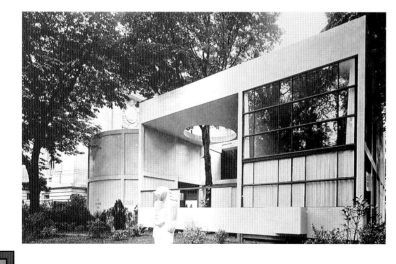

Left: *the Pavillon de L'Esprit Nouveau at the 1925 Paris Exposition Internationale des Arts Décoratifs et Industriels Modernes. A two-storey living space with a sleeping gallery, it was designed by Le Corbusier and Pierre Jeanneret, and expressed simply their desire for standardisation and quality in modern low-cost housing design*

Although Walter Gropius had founded the school by combining the Weimar Academy of Arts with the School of Applied Arts in 1919, the architecture department (*Hochschule für Gestaltung*) was not established until 1927. The Bauhaus was established in Weimar until 1925 when it moved to Dessau on the promise of better financial support. It then transferred to Berlin in 1932 before being forced to close in 1933 by the Nazi regime.

Although Gropius had designed the administrative and residential quarters at Dessau, the richly diverse remit of the Bauhaus workshops officially did not include the teaching of architecture until the appointment of Hannes Meyer as chairman, in 1927. Gropius resigned the following year, whereupon Meyer became director. He held this position until 1930 when he was forced to resign, being replaced by Ludwig Mies van der Rohe who held it until the Bauhaus closed in 1933.

The Bauhaus soon came to command an astonishingly far-reaching respect and influence. Its didactic method was based on the assumption that, if one could design anything one could design everything, and its workshops' products became widely copied and reproduced.

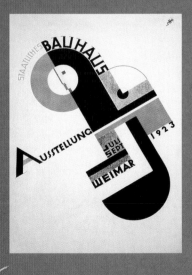

Above: a poster advertising the Bauhaus summer exhibition of 1923

Below: the main façade of the Academy of Fine Arts building, Weimar. It was designed by Henry van de Velde and built between 1904 and 1911. Its severe, factory-type studio windows with exposed lintels dominate but are very efficient

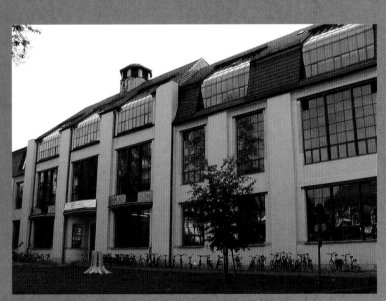

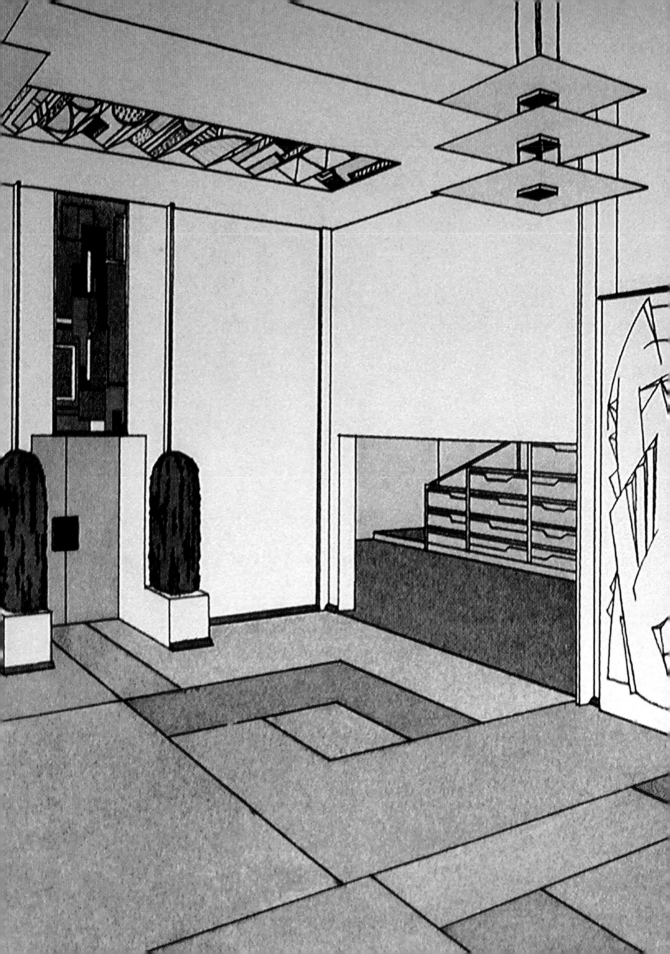

PARIS 1925

WHAT MIGHT BE TERMED HIGH ART DECO had already attained its peak by the time of the renowned 1925 Paris Exposition. This event, which eventually gave the movement its name, was a showcase for the leading French interior designers. These included Charlotte Chauché-Guilleré, who was then a decorator working for Atelier Primavera, the design studio of the Parisian department store Au Printemps; *ensembliers* and furniture makers, including Jacques-Émile Ruhlmann. He was the best known cabinet-maker of his day, and took part along with more *avant-garde* figures such as the industrious Robert Mallet-Stevens, and the younger designer-architect Pierre Chareau. The latter had made his début at the 1919 Salon d'Automne, and later created the celebrated Maison de Verre.

However, the Exposition Internationale des Arts Décoratifs et Industriels Modernes had been a long time in the making, having been conceived originally as early as 1907. It proceded to the planning stage, and was scheduled to be held in Paris but the irruption of war caused it to be shelved. It was rescheduled for 1922, a date that was delayed again, until 1924, before finally being arranged for April to October 1925.

The exhibition was therefore held, ironically, at the very moment when the pure or high Art Deco style was

Left: a design for a French embassy, L'Ambassade Française, which was exhibited at the 1925 Paris Exposition. This entrance hall was designed by Robert Mallet-Stevens, who was just one of the many contributors

already approaching its end, but this did not dissuade the numerous artisans involved from showing to the world that indeed France had succeeded in creating a new design vocabulary. Their set-piece interiors ranged between creations as diverse as Maurice Dufrène's magnificent bedroom for a woman, in white maple with silks and polar-bear skins, and George Champion's aggressively rectilinear black-and-yellow dining-room, but everywhere the keynote of the French pavilions was luxury, with exotic woods and unusual materials being predominant.

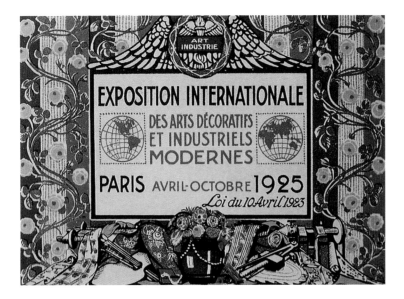

Left: a leaflet design for the 1925 Paris Exposition

At the Exposition the leading exponents of France's modern furniture movement, from the cabinet-makers of the Faubourg Saint-Antoine to the country's top designers, were positioned along the Pont Alexandre III, the rue des Boutiques, and the Esplanade des Invalides on the Left Bank. The only notable exceptions not aligned with the principal furniture designers and manufacturers were Poiret, and Le Corbusier. The former preferred to exhibit his theatrical interiors housed on three barges, which were moored at the Quai d'Orsay. These barges, named *Amores*, *Délices* and *Orgues*, were fitted out by the Atelier Martine with mural decorations

printed on linen from designs by Raoul Dufy. On the other hand, the Exposition's organising committee so disliked the Pavillon de L'Esprit Nouveau by Le Corbusier that it was banished to the Right Bank, and a high board fence was erected in front of it for the opening ceremony so that it could not be seen.

The major French exhibits were in the Esplanade des Invalides, a park in front of Les Invalides, where visitors were able to explore pavilion after pavilion; each of these was set within its own expanse of lawn, complete with garden statuary.

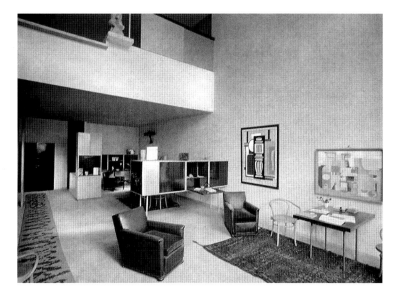

Right: the interior of L'Esprit Nouveau, also designed by Le Corbusier. Equipped with office furniture, it had inexpensive bentwood chairs by Thonet. The paintings hanging on the walls were by Amédée Ozenfant, and were in the Purist style; together he and Le Corbusier had founded the movement, the aim of which was to 'inoculate artists with the spirit of the age'

Pride of place went to the top Parisian department stores: Bon Marché, Au Printemps, and Galeries Lafayette, each of which had art studios to design and furnish pavilions, but between were those of the private exhibitors.

Among these were L'Hôtel d'un Collectionneur of Ruhlmann, which the critics acclaimed as the most spectacular in preference to many other brilliant designs such as Un Musée d'Art Contemporain from Louis Süe and André Mare (Süe et Mare); L'Ambassade Française pavilion, arranged by the Societé des Artistes Décorateurs; and the pavilion of René Lalique.

The metalworker Edgar Brandt had his own pavilion

Above: one of many interior doors produced for the 1925 Exposition by the ironworker Edgar Brandt

on the Esplanade des Invalides, but he also contributed to several other pavilions for which he produced decorative panels, gates and screens. His masterpiece for the Exposition was undoubtedly the main entrance to the event, La Porte d'Honneur.

René Lalique's display in his own pavilion, which was decorated with bas-reliefs in glass, included the full gamut of his creative work from drinking glasses to scent bottles. His contributions elsewhere at the Exposition included the fountain, fashioned in the form of a glass obelisk, which occupied a site on the Esplanade des Invalides and was illuminated at night. He also provided sculpted glass panels which were incorporated into La Porte d'Honneur, a dining-room with a coffered ceiling in glass for the Sèvres pavilion, and another glass sculpture in the form of a fountain for the Parfumerie Française stand in the Grande Palais.

L'Hôtel d'un Collectionneur by Ruhlmann included magnificent examples of his furniture, often regarded as being the epitome of Art Deco. Alongside his own work were displayed complementary *objects d'art* such as sculptures by Émile-Antoine Bourdelle, Charles Despiau and Joseph Bernard; murals by Jean Dupas; gates by Brandt; *pâte-de-verre* by François-Émile Décorchemont; pottery by Émile Lenoble and Émile Decœur; silver by Jean Puiforçat; marquetry by Henri Rapin, and lacquerwork by Jean Dunand and Pierre Legrain.

L'Ambassade Française was sponsored by the Ministère des Beaux-Arts, which made a grant to the Societé des Artistes Décorateurs to furnish and decorate the rooms of an imaginary ambassador's house. This was also erected on the Esplanade des Invalides and, like most of the others, was constructed in plaster on wooden frames. Its contributing artists included the *crème de la crème* of the French *avant-garde*.

The entrance hall was designed by Robert Mallet-Stevens. The smoking room, with its orange rug, Dunand's black lacquered furniture and a ceiling decorated in silver leaf with tips of red lacquer was by Francis Jourdain, who was also responsible for the design of the

gymnasium. Also in the smoking room was a figure of the Swedish dancer Jean Borlin modelled by Jan and Joël Martel, and a Dunand lacquered screen to a design by Jean Lambert-Rucki.

In the dining room of L'Ambassade the table was laid with a silver centrepiece by Jean Puiforçat, and a china service decorated with a design created by Henri Rapin. There were exquisitely beautiful Jules Leleu chairs in both the music room and in the salon, where there were silk wall hangings with motifs of fountains and flowers, designed by Édouard Bénédictus.

There were other rooms, with furniture by Léon-Albert and Maurice-Raymond Jallot in the reception room and bedroom; by Pierre Chareau in the *bureau-bibliothèque*; and by André Groult in the *chambre de madame*. There

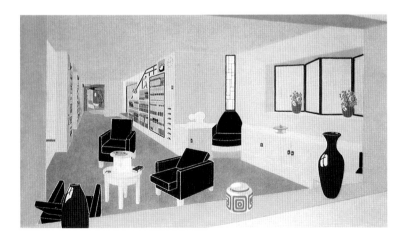

Left: *one of two smoking rooms that were featured in L'Ambassade Française pavilion at the 1925 Paris Exposition; this one was by Francis Jourdain, the other was by Jean Dunand*

were sculptures by Roger de la Fresnaye and paintings by Marie Laurençin. The ante-chamber to this singular residence was furnished and decorated by Paul Follot in collaboration with Pomone, the studio of which he was a director.

All in all, L'Ambassade Française was a residence bedecked and bejewelled with items that were well beyond the reach of the vast majority of the visitors to the 1925 Exposition, for French high Deco was beautifully designed, hand-crafted from very expensive materials and definitely only for the seriously rich.

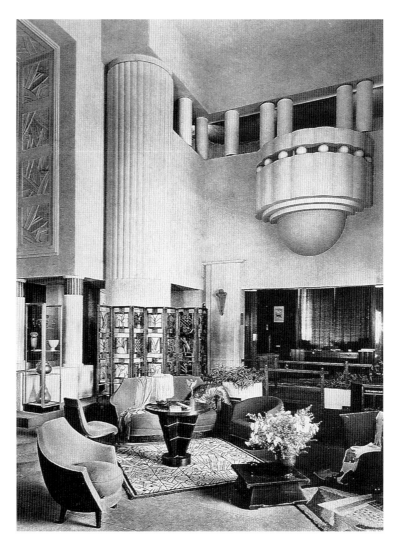

Right: the hall in the pavilion of Atelier Primavera was designed by A Lévard

Right: the dining room in the Pavillon de la Maîtrise, which was designed by Maurice Dufrène

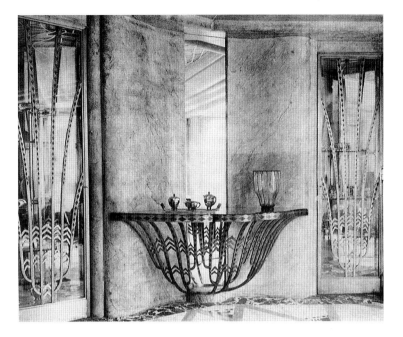

A step down from such extravagances, available to the moderately rich, were the services of the design studios. Four such decorating *ateliers* had been established by the leading Parisian department stores: Au Printemps had Atelier Primavera under the direction of Mme Chauché-Guilleré; Galeries Lafayette had La Maîtrise, opened in 1921 under the direction of Maurice Dufrène; Bon Marché followed in 1923 with Pomone; and finally there was Studium-Louvre, where the leading designers were Djo-Bourgeois and Etienne Kohlmann.

These studios offered a full Art Deco service to their customers, providing a personally-designed and coordinated home which would include everything from complete suites of furniture, through carpeting, wall-coverings and lighting, right down to the flower vase and the knife and fork. In this way the studios drew upon the multi-versatile talents of their designers, the concept of harmonious design promoted by the German exhibits at the 1910 Salon d'Automne, and a unity between the designer and manufacturer, as the department stores also took responsibility for the potters, weavers and cabinet-makers with whom they worked.

Far right: a model of the Monument to the Third International, 1919–20, by Vladimir Tatlin. This is a fantastical design that could not have been built; abstraction in architecture. The proposed steel and glass structure, over 305m (1,000ft) high, was to enclose congress halls and offices, and was painted red

Right: the Russian pavilion at the 1925 Paris Exposition was one of the most progressive buildings of the show; it was designed by Konstantin Melnikov. One of the few practical examples of the Russian Constructivist theories, it had intersecting masses composed to emphasize the diagonal: the wooden staircase on the right of the picture cut diagonally through the rectangular building

Elsewhere, there was Un Musée d'Art Contemporain, designed in the form of a classical rotunda, and decorated by Süe et Mare as a showcase for the products of the Compagnie des Arts Français, which had been founded by Süe and Mare in 1919. In addition, Christofle, the goldsmiths and silversmiths, shared a stand with the Baccarat glassworks, displaying tableware in hammered silver designed by Paul Follot, Süe et Mare and Christian Fjerdingstad.

There was also a Pavillon d'Elégance, where there were displays of feminine clothing. Outer garments, underwear and accessories were arranged in a stand designed by Jeanne Lanvin, who was also one of the exhibitors. The stand was decorated with lacquered screens by Jean Dunand and furniture by Armand-Albert Rateau. The jewellery houses of Boucheron and Cartier endeavoured to provide yet more temptation.

Sèvres had its own faience-clad pavilion, in which it exhibited a startling variety of porcelain and stoneware, whereas the porcelain manufacturers from Limoges shared another pavilion. The Daum glass factory was yet another of the large manufacturers to exhibit.

The 1925 Exposition was not, however, entirely a French offering. Some of the exhibits from other nations showed distinct signs that Art Deco had invaded their contemporary culture. Although Germany had not been invited to participate and the government of the USA declined its invitation, Japan and China did participate as representatives of Asia, while the then French colonies represented African countries.

In the Austrian pavilion, the Wiener Werkstätte showed designs that were of a more graceful style than the severe geometry of its earlier work, while the Czechoslovakian exhibit reflected the Cubist manner of pre-war Prague. Belgium surprised with a design created by Philippe Wolfers, the basis of which was the ten-sided polygon – a motif he used and repeated everywhere, in a decidedly Art Deco effect – on flooring, carpets, tables, china and for the drinking glasses. In the same genre was the Belgian company Boch Frères' work using

its unique highly stylized animal and flower decoration.

However, although Art Deco was absolutely prevalent throughout the Paris Exposition, there was also the anticipated presence of the upcoming Modernism, despite the organisers' refusal to acknowledge it. This had resulted in the tucking away out of sight of Le Corbusier's Pavillon de L'Esprit Nouveau, that clearly demonstrated both *de Stijl* and Bauhaus ideals. The most aggressively modern exhibit of all was the Russian pavilion, designed in the Russian Constructivist style by Konstantin Melnikov and painted red in memory of Vladimir Tatlin, the style's founding father.

Auguste Perret designed a theatre for the Exposition, and there was also a Pavillon du Tourisme, which was designed by Robert Mallet-Stevens. This was inspired by the sketches of Antonio Sant'Elia, and combined a Modernist doctrine with a decorative Cubist style, including low relief sculpture by Jan and Joël Martel. The furniture in this pavilion was designed by Francis Jourdain and Pierre Chareau.

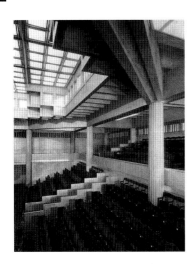

Above: the theatre interior

The impact of the Exposition Internationale des Arts Décoratifs et Industriels Modernes was quite without precedent, on both the general public and international critics. No previous world fair had had quite the impact that this 1925 event, which had covered a huge area in the centre of Paris, was to have. Its overall organisation was the work of its chief architect, Charles Plumet, and Louis Bonnier, who was in charge of landscaping.

The fair's main gate, La Porte d'Honneur, was next to the Grand Palais and led through the fair across the River Seine via the Pont Alexandre III, and down the long Esplanade to the Place des Invalides. Along the route, including sites on the bridge and at moorings in the Seine, were over 130 individual showplaces of artistic, commercial and industrial establishments, while

hundreds more individual artists, manufacturers and commercial establishments displayed their wares in the massive Grand Palais. More than 20 nations from all around the world participated.

In terms of its influence as a single event on subsequent trends in design and architecture, the 1925 fair was to be unsurpassed in the twentieth century. Many of the major pieces of furniture were recognised immediately for the masterpieces they were, and were purchased directly by the Musée des Arts Décoratifs or the Metropolitan Museum of Art in New York.

Although fairs continued to be held in Europe throughout the 1930s the most important, in terms of Art Deco style and architecture in particular, was the 1933 Century of Progress Exposition held in Chicago.

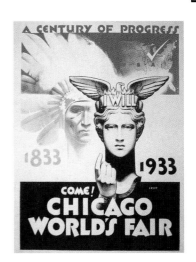

Left: bas-reliefs in the Pavillon du Tourisme, which was designed by Robert Mallet-Stevens, depicting four different modes of transport

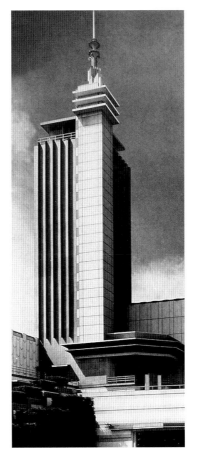

Right: the Hall of Science pavilion, designed by Raymond Hood, at the 1933 Chicago Century of Progress Exposition, the theme of which was science in industry. These high pavilions combined elements of the traditional neoclassical with the streamlined modern

Above: a poster that exhorts attendance at the 1933 Chicago World's Fair, which marked the centenary since this midwestern city had been founded. Its theme, though it was ostensibly to celebrate a centenary, laid more emphasis on the past 40 years in science and technology. The event was a huge success, with some thirty-eight million people visiting during its duration of 17 months

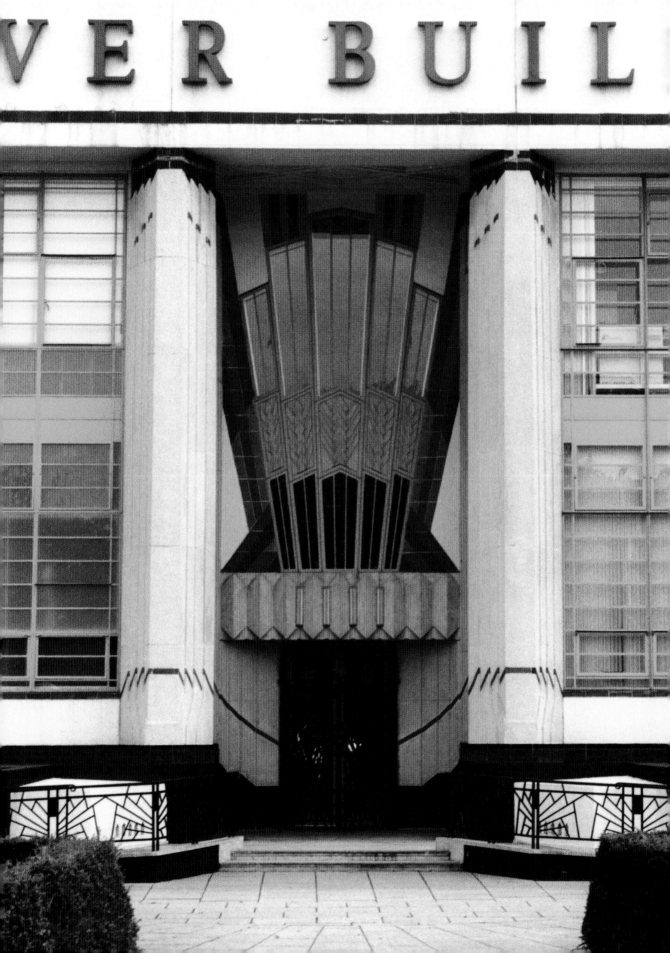

ARCHITECTURE

ALTHOUGH ART DECO IS BEST KNOWN to its wider public in the form of smaller objects such as ceramics, textiles and posters, it is in the larger commissions that the style may be best appreciated to its full potential. These range from the fully all-encompassing 1925 Paris Exposition to the final luxuriant throes of the style, in the form of the elegant ocean-going liner *Normandie*.

Only occasionally had Art Deco motifs been applied to Parisian buildings prior to the 1925 Exposition. They had been used infrequently and randomly, the style appearing here and there, most usually as a boutique façade – typically of perfumeries. There was never any conformity of styling, as architects and designers followed their own individual separate paths of development. Such arrangements could be seen in the use of opulent bas-reliefs by Süe et Mare, the colourful Parisian shop façades decorated by Siegel and Atelier Martine, and the restrained angular forms of the decoration used by the architects René Prou, Édouard-Joseph Djo-Bourgeois and Jean Burkhalter.

There was very little else architecturally in France, especially outside of the capital. Surprisingly however, the style did form some architectural roots in England, although in a modified interpretation of the perceived pure French form of Art Deco. This produced some

Left: the main entrance to the Hoover Building, a factory by Wallis Gilbert at Perivale, Middlesex, built in 1932–36, and only recently restored under different ownership. After earlier catastrophic demolitions, this is almost certainly now Britain's most renowned example of architecture in the Art Deco style

rue Mallet-Stevens (group of six houses), Auteuil, Paris, 1926–27, by Robert Mallet-Stevens
Girault (shop), boulevard des Capucines, Paris, 1928, by Azema, Edrei & Hardy
Société Financière Française et Coloniale (offices), rue Pasquier, Paris, 1929, by Georges Saupique
Villa Savoye (house), Poissy-sur-Seine, 1929–31, by Le Corbusier and Pierre Jeanneret
Maison Barillet (house), 15 Square Vergennes, Paris, 1932, by Robert Mallet-Stevens, with elongated leaded-glass window by Louis Barillet
School, rue Kuss, Paris, 1934, by Roger-Henri Expert
16 rue Chardon-Lagache (apartment building), Paris, 1934, by J Hillard with bas-reliefs by Georges Chiquet

Above: houses in rue Mallet-Stevens

Below: Le Corbusier's Villa Savoye, originally known as Les heures claires (The Daylight Hours), was built as a country home for M and Mme Pierre Savoye. It was listed as a public building in 1964

Right: the façade of the Girault beauty parlour

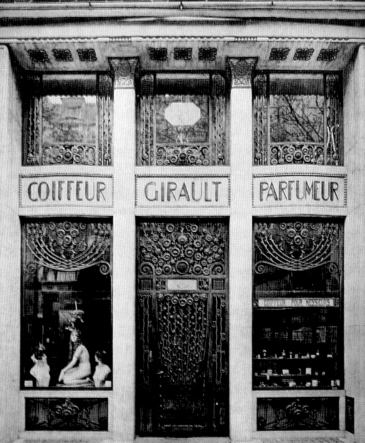

New Ways (house), Northampton, 1926, by Peter Behrens

Chaumet (shop), Berkeley Square, London, 1926, by Joseph Emberton (demolished)

Firestone Tyre Factory, Brentford, Essex, 1929, by Wallis Gilbert and Partners (demolished)

Daily Express Building (newspaper offices), Fleet Street, London, 1930–32, by Sir Owen Williams with Ellis & Clarke

Broadcasting House (recording studios), Portland Place, London, 1930–32, by G Val Myers, with external sculpture by Eric Gill

Midland Hotel, Morecambe, Lancashire, 1932–34, by Oliver Hill

Hoover Building (factory), Perivale, Middlesex, 1932–36, by Wallis Gilbert and Partners

Lawn Road (flats), Hampstead, London, 1933, by Wells Coates

High Point 1 (high-rise flats), Highgate, London, 1933–35, by Berthold Lubetkin and Tecton

Ventilation Station, Mersey Tunnel, Liverpool, 1934, by Herbert J Rowse

Penguin Pool, London Zoo, Regent's Park, 1934, by Berthold Lubetkin

Gillette building, London, 1936, by Sir Banister F Fletcher

Finsbury Health Centre, London, 1938, by Berthold Lubetkin and Tecton

Above: the black Vitrolite and glass-clad Daily Express Building, London, 1930–32, by Sir Owen Williams with Ellis & Clarke

Below: the façade of the ladies' boutique Madelon Chaumet, 35 Berkeley Square, London, 1926, by Joseph Emberton

Below left: the façade of the Hoover Building

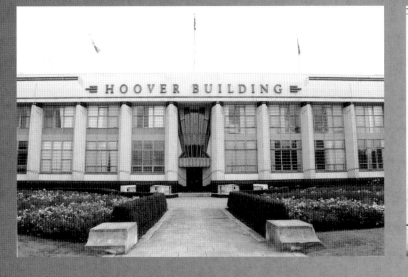

Below right: the 51-storey RCA Victor Building (now General Electric Building), New York, 1931, by Cross & Cross. It was constructed in limestone and salmon-coloured brick and it embodied a plethora of Art Deco detailing, from allegorical and stylized figures to thunderbolts and zig-zags

period classics, beginning with the early Savoy Theatre, London, 1920, with its Egyptian-revival statues and urns; the ballroom in the 325-bedroomed Park Lane Hotel, Piccadilly, London, 1927, by Adie and Button; the Strand Palace Hotel, London, 1930, with its dazzling entrance of angled illuminated glass panelling by Oliver Bernard, which is now preserved in the Victoria and Albert Museum, London; and the Hoover Building factory, Perivale, 1932, with its colourful Aztec-Egyptian motifs.

Despite some excellent architectural examples of Art Deco in both France and England, without question it was in North America that the style was at its most expressive and dramatic. In the great architectural cities of New York and Chicago, the stepped skyscrapers, pointed turrets, decorative finials and geometric friezes came to epitomise the Deco style.

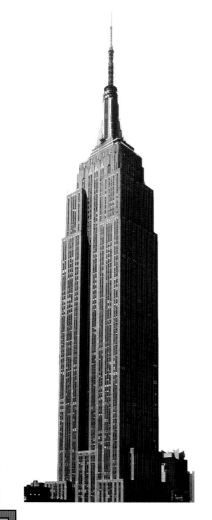

Left: skyscraper design for a commercial building had to give sufficient accessible office space to make the venture cost-effective. The ultimate expression of this was the Empire State Building, New York, 1930–32. At 381m (1250ft), this was the tallest building in the world between 1932–1971; of its 102 storeys, 86 were offices. Laws introduced in New York in 1916 required that the storeys above a certain height should be set back from the edge of the building plot to allow for light at street level, and resulted in the stepped profiles associated with Deco-styled skyscrapers

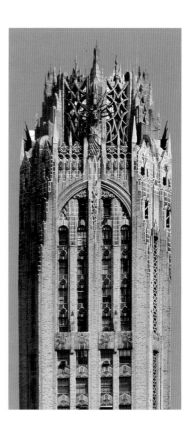

It was not limited merely to the towering structures that characterise these great cities, but although it did spread to embrace the new phenomenon of cinemas, in addition to department stores, hotels and even private housing, undeniably the most complete expression of Art Deco architecture in the United States was achieved in the skyscrapers. These included such beautifully executed examples as the Chanin Building, 1928–29; the Chrysler Building, 1928–29; the Empire State Building, 1930–32, and the Rockefeller Center which itself includes the Radio City Music Hall, 1931–40. All of these structures graced the skyline of New York City, although elsewhere in America almost every major city and town once boasted at least one important Art Deco structure.

These new statements of power, might and energy were given a catalyst in 1922 when the *Chicago Tribune*

Below left: the upper façade of the blue-green terracotta-clad Eastern Columbia Building, Los Angeles, 1930, by Claude Beelman. This building originally housed four floors of shops, as well as offices, an auditorium, a restaurant and other staff areas, and is terminated in a clock tower

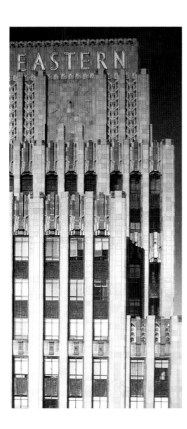

Right: the original design for the Chrysler Building, New York, was drawn up for the building contractor William H Reynolds in 1926. It was sold eventually to Walter P Chrysler, who wanted a provocative building that aimed to 'positively pierce the sky'; 77 floors made it the tallest building in the world prior to the completion of the Empire State Building. Its crowning peak became the star of the New York skyline when William Van Alen pre-assembled the seven-storey pinnacle inside the building, and in just 90 minutes raised it through the roof opening and anchored it on top

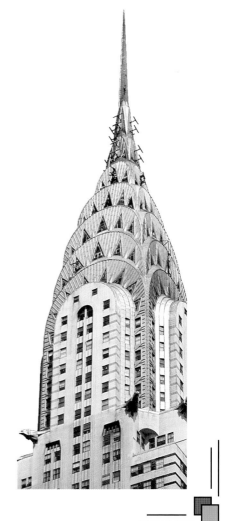

Above: Bullocks Wilshire's department store in Los Angeles was designed by Parkinson & Parkinson in 1929 in the fashionable stepped Modernist-Art Deco style, inspired by the 1925 Paris Exposition and by the ideas from the Chicago Tribune Tower competition

newspaper initiated a worldwide competition for what it ambitiously announced as 'the world's most beautiful office building'. Nearly 300 competition entries were received in an incredible range of building styles, but the winners of the $50,000 first prize were the partnership of Raymond Hood and John Mead Howells. Their entry, which was completed in 1925, was unequivocally a disappointingly retrograde solution, the roofscape being a combination of finials, flying buttresses and stunted towers in a late medieval style replete with tracery and pierced stonework. Although this approach did produce a building of familiar style and some dignity, sadly it also represented a victory for conservatism at a time during these inter-war years when a programme of new and potentially exciting large-scale building was launched.

The jury's choice seems even stranger when they placed the design by Eliel Saarinen second in the competition. This was a soaring stepped-back Modernist design that achieved its unity through a vertical linear emphasis on solid structure opposed to vertical window voids, the stepped set-backs carrying the voids through to the roofline, thus continuing the emphasis. The high point of the roof terminated in a decorative horizontal block, and this was quickly adopted to become the prototype for the numerous Modernist skyscrapers which sprang up across America through the next ten years.

This new vision therefore subjected the form of the skyscraper to a metamorphosis, and as the period advanced, so Art Deco advanced with it to become a fashionable decorative style. It was as if the Tribune Tower had become a rallying point for the proponents of *avant-garde* architectural ornamentation. The competition helped the architectural community to focus on a self-evident fact: in order for the country's architecture to come of age it had first to divest itself of all traces of past, foreign, influence. The Tribune Tower was, *ipso facto*, out of place the moment it was built; all neoclassical decoration had been rendered *passé*, it belonged not to a modern America, but to a bygone era, and architects began to search for a new form of

decoration, and one that was more in sympathy with twentieth-century building materials.

As the period advanced and Art Deco became the fashionable decorative style, its forms began to be incorporated in the two areas where they would be most evident: in the ground-level entrances and circulation areas, and on the roof structure. One example of the latter is the pinnacle of the Chrysler building, with its unique rising fan shapes on a square plan.

The Chrysler Building was to become a classic, being the most successful on its own terms of the late-1920s structures, and it remains an archetypal example of Art Deco style. The building's soaring tower is sheathed in shiny nickel-chromed steel in a design of overlapping arcs, punctuated by triangular windows which are stepped inwards, and it ends in an arrow-shaped spire. Just below, at the fifty-ninth floor level, an octet of stylized steel eagles play the role of modern gargoyles. Further down, at the thirty-first storey level, the exterior brickwork forms patterns of streamlined automobiles.

Photographic motion pictures projected onto a screen had become available to the general public from about 1895, and were shown either as fairground attractions or as items in music-hall programmes. Films had increased in length from a few minutes to two hours by 1914, but during the war the demand for films grew at a time when European producers were least able to meet that need. The American industry was quick to take advantage of this and the United States became the foremost film-making country, with Hollywood being established as the chief centre of production.

During the 1920s the United States consolidated its position, and the cinema became the people's entertainment. By the late 1920s sound films had been developed, and by 1932 a three-colour process, trademarked as Technicolor, had made its début.

Given this history, it is not surprising that cinemas from the outset were designed in the latest, most modern, Art Deco style. Firstly and mostly in the United States, but also in Britain, and to a very limited extent in

Far left, below: it could only be right that the Chrysler cathedral should have its own gargoyles; Van Alen's eagles, built in chromium nickel steel, have their eerie at the fifty-ninth floor level of the building. He also included symbolic car designs, including winged bonnet ornaments, hubcaps and patterned brickwork. The Chrysler building has become the iconic Art Deco skyscraper

Below: Academy cinema, Inglewood, Los Angeles, by S Charles Lee featured a 38.1m (125ft) fluted chimney wrapped in a snaking spiral and topped by a three-dimensional sun

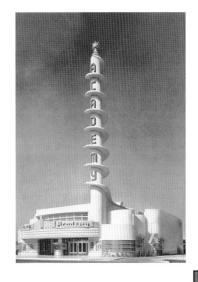

New York Telephone Co. building (now Barclay-Vesey), New York, 1923–26, by Ralph T Walker; a modern stepped structure, it was the first important Art Deco office building

American Radiator building, New York, 1924, by Raymond M Hood; sheathed in black brick with gilded stone detail

Graybar building, New York, 1926–27, by Sloan & Robertson; has dramatic bas-reliefs of classical gods

Hearst Magazine building, New York, 1927–28, by Joseph Urban; surmounted by zigzag-decorated urns

N W Ayer & Son headquarters, Philadelphia, 1927–29, by Ralph B Bencker; a façade that has a rich symbolic sculpture with figural pylons holding open books

Chesapeake and Potomac Telephone Company, Washington, 1928, by Ralph T Walker; modern and stepped, with fluted pilasters and bas-reliefs

WCAU building, Philadelphia, 1928, by Harry Sternfeld and Gabriel Roth; a façade of blue-glass chips set in plastic and studded with metal bands like electric volts, topped by a bold glass tower which glowed blue at night

Chanin Building, New York, 1928–29, by Sloan & Robertson; decorated by Chambellan and Delamarre

Fuller building, New York, 1928–29, by A Stewart Walker and Leon Gillette; a white brick, set-back structure with black detailing, surmounted by zigzag and sun-like patterns of vaguely Aztec origin. Its street level entrance is dominated by a clock and figures by Elie Nadelman

Richfield Oil (now ARCO) building, Los Angeles, 1928–29, by Morgan, Walls & Clements; clad in glazed black and gold terracotta, with a tower of lacy metalwork on top

Film Center, New York, 1928–29, by Ely Jacques Kahn; this architect designed almost 40 commercial structures in the city. This is representative of nearly all of them which were marked, both inside and out, by a distinctive geometric vocabulary; others include the Squibb building, 1929–30, and the Holland Plaza building, 1930

Chrysler building, New York, 1928–29, by William Van Alen

Western Union building, New York, 1928–30, by Ralph T Walker; an exuberant Art Deco structure, clad in bricks that range through 21 colour variations, it has entrance arches with concertina forms

Above: the façade of the International Building at the Rockefeller Center is adorned by a group of fifteen hieroglyphs in limestone by Lee Lawrie, representing the four races of man, and aspects of art, science, trade and industry

Daily News building, New York, 1929–30, by Raymond M Hood; the closely-set verticals are stressed

Eastern Columbia building, Los Angeles, 1930, by Claude Beelman; blue-green terracotta with gilding

Threefoot building, Meridian, Mississippi, 1930, by C H Lindsley; coloured terracotta scrolls, sunbursts and zigzags

Market Street National Bank (now One East Penn Square), Philadelphia, 1930, by Ritter & Shay; Mayan Revival motifs in turquoise, orange and white terracotta

Southern New England Telephone Company buildings, Hartford, Connecticut, 1930, by R W Foote; zigzag motifs, metal grillework and stone sculptures

500 Fifth Avenue, New York, 1930-31, by Shreve, Lamb & Harman; smoky-black terracotta spandrels define the vertical mid-section of its buff terracotta face

McGraw-Hill building, New York, 1930–31, by Raymond M Hood; one of the architect's finest skyscrapers designed in the International Modern style

Empire State building, New York, 1930–32

Niagara Mohawk Power Corporation building, Syracuse, 1930–32, by Melvin L King with Bley & Lyman; shiny metal, including figure by Clayton Frye, on a limestone façade

RCA Victor Building (now General Electric), New York, 1931, by Cross & Cross; allegorical and stylized figures, thunderbolts and zig-zags included in its Deco detailing

Rockefeller Center complex (includes the RCA Building, 1934; offices; Radio City Music Hall; shops; restaurants; sunken plaza; gardens), New York, 1931–40. Designed by a group of architects including Hood; 14 original limestone piles are set with metal spandrels and highlighted with gilded and polychrome, largely Art Deco, allegorical sculptures. They were created by sculptors including René Paul Chambellon, Leo Friedländer, Alfred-Auguste Janniot, Lee Lawrie and Paul Manship

Kansas City Power and Light Co. building, 1932, by Hoit, Price & Barnes; a sunburst and scrolled tower topped by a glazed pyramid that glowed orange

Brownley's store, Washington, 1932, by Porter & Lockie; adorned with typical Deco motifs of zigzags, sunbursts and stylized flowers and scrolls

Below: the sculptor Lee Lawrie also executed the triptych surmounting the entrance of 30 Rockefeller Plaza. This had at its centre a figure representing Wisdom, who was flanked by Sound and Light. Beneath were blocks of glass bonded by Vinylite (a type of PVC, polyvinyl chloride), and reinforced by steel rods, which was made by Steuben Glass

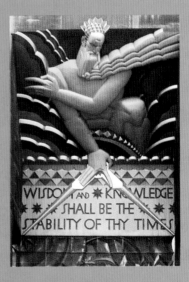

Far right, above: *the fascia of the Grandview Theatre, St Paul, was typical of the period's twin obsessions, the Art Deco style and the cinema*

Below: *two views of the interior of the Wiltern Theatre, Los Angeles, 1929–31; this utterly and absolutely Art Deco piece was by S Charles Lee*

Europe, these buildings dedicated to the film-makers' art usually boasted, among the many attention-seeking elements, geometric lighting fixtures, a profligate use of mirrors, and stylized murals and curtain designs.

The biggest, and the best, Art Deco cinemas were appropriately to be found in California, and included such excellently lavish examples as the Avalon Cinema, Catalina Island; the Wilton Theatre and the Pantages Theatre, both in Los Angeles; and the Paramount Theatre, Oakland, which was designed by Timothy L Pflueger.

However, it was not purely in Hollywood's home state that these innovatively-styled movie palaces appeared, for all the way from coast to coast across America the cinema owners were erecting glittering theatres in which to offer entertainment to the masses, and in so doing, to provide a palliative to life's daily grind.

If anything, cinema and theatre extravagance was overdone during the 1920s, in an effort to recreate the fantasy land that films portrayed; even their names, such

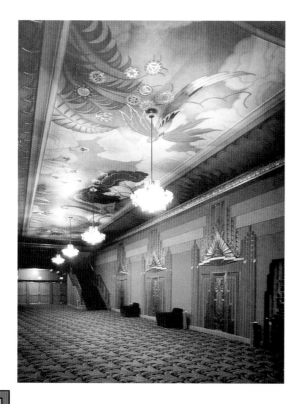

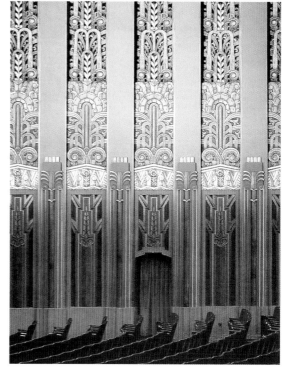

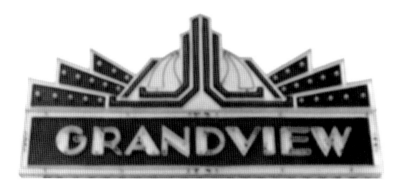

as the Alhambra, the Coliseum, Palace and Ritz suggested illusion and glamour on a grand scale, but grudgingly they gave way in the 1930s to the age of the Streamlined Modern movie theatre.

These wholly contemporary forms were streamlined, aerodynamic, and strongly expressive, and thus very apt when applied to buildings related to travel. They fitted perfectly with the images of sleek locomotives, gleaming car bodies, and giant-prowed ocean liners. They completed the new vocabulary of images that modern travel conjured up. These transport-connected buildings presented an ideal opportunity to develop exuberant Art Deco railway stations, bus termini, petrol stations and, in London, Underground railway stations.

Once more the genre was American-led. Such magnificent examples appeared as the huge, domed, Cincinnati Union Terminal, 1929–33, by Fellheimer & Wagner, with its ornate interior and stepped exterior that sports a huge numberless clock. The building was not unlike the architects' earlier New York Central Terminal at Buffalo, 1927–29. Stylized relief decoration also adorned the stepped, Cubist, glazed terracotta mass of the Omaha Union Station, Nebraska, 1929–30, while Art Deco ornamentation proliferated all over the 13-storey Texas & Pacific Passenger Terminal, Fort Worth, 1931.

In London the Underground stations were designed in a modified Modernist manner, mostly under the direction of Charles Holden. The first of these was the two-storey Clapham South (originally Nightingale Lane) station, 1925–26, which had a tri-faceted limestone façade. By 1932 Holden's red brick boxes, each topped by a cylindrical tower, had become familar travel beacons that stretched across the capital, from Arnos Grove to Park Royal.

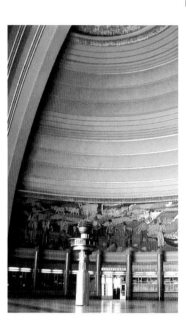

Above: Cincinnati Union Terminal, 1929–33, by Fellheimer & Wagner featured a domed interior above a glass-mosaic mural by Winold Reiss

Below: the Underground station at Park Royal, London, 1932, by Charles Holden

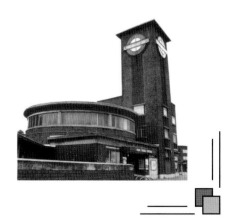

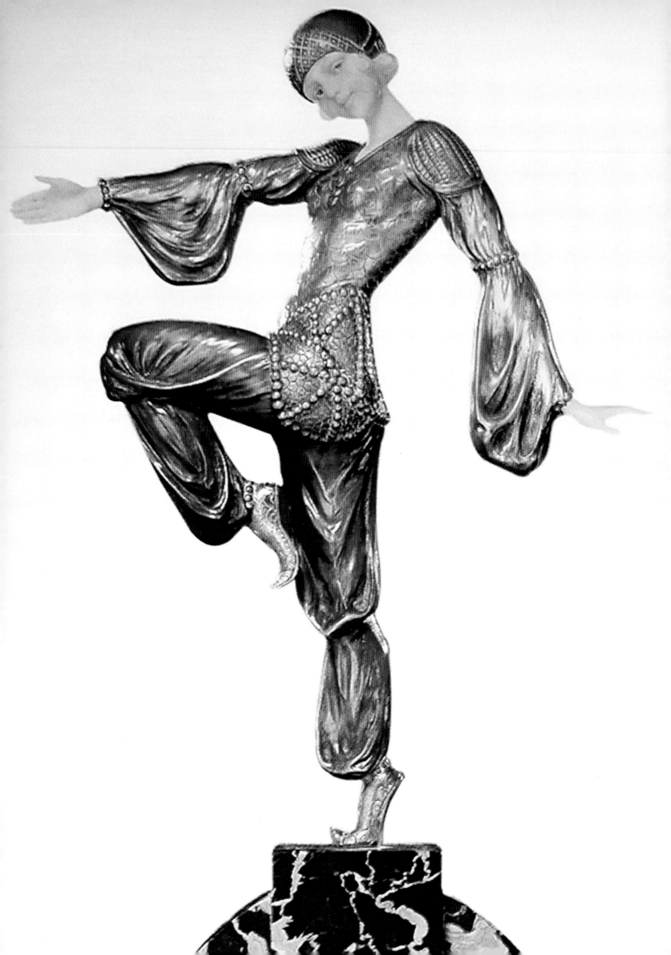

SCULPTURE & CERAMICS

DURING THE ART DECO PERIOD the majority of sculptors worked in bronze and stone, yet the most spectacular decorative figure work was created in chryselephantine (ivory and cold-painted bronze). The medium was most popularly produced by artists working in Paris and Berlin, and has since grown to become synonymous with Art Deco, although the first official public display of modern chryselephantine sculpture is generally recognised as having been at the 1897 Colonial Museum exhibit of the Brussels (Tervueren) Exposition Internationale.

In 1906 Ferdinand Preiss founded a workshop in Berlin with Arthur Kassler, and here he created beautifully-executed statuettes, usually female and often exotically clad, which were mounted on elaborate marble or onyx bases. The facial features were painted onto the ivory which had been carved by hand and polished. The cast-bronze sections were also usually painted, and the finished pieces were miniature masterpieces.

Preiss himself designed most of the models produced by the Preiss-Kassler firm. His early pieces, which were mostly small in scale, were of classical figures.

Left: Charm of the Orient, *a 1920s bronze and ivory figure by A Godard*

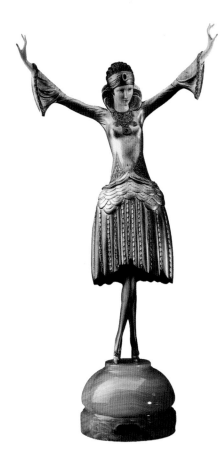

The firm was closed for the duration of the war, but when it re-opened in 1919 his style developed and expanded to include the depiction of more contemporary and popular figures: children, acrobats, dancers and athletes.

Preiss-Kassler acquired its rival company Rosenthal und Maeder in 1929, together with its designers, but also commissioned models from Paul Philippe, Otto Poertzel, R W Lange and other prominent artists.

Demêtre Chiparus was the Parisian counterpart to Preiss, a Romanian who had left his native country for the bright lights and shining dance-halls of Paris. Chiparus became a master of bronze and ivory sculpture, specialising in pieces that depicted contemporary artists such as cabaret performers, and Vaslav Nijinsky of the *Ballets Russes*. However, his work differed to that of his Berlin counterpart in that Chiparus designed on a fairly large scale, and his emphasis was directed to the jewel-like surface treatment that was applied to the bronze costumes of his figures, rather than to the quality of his carving.

Both of these major artists produced limited editions of their work, rather than unique pieces, and when they proved popular, the designs were quite often also

Above: Danseuse au Bandeau *(Dancer with Turban) by Paul Philippe, a jewelled cold-painted bronze and ivory figure which was produced from 1929 by both the Preiss-Kassler and the Rosenthal und Maeder workshops, for differing markets*

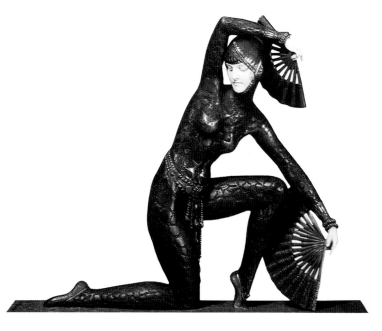

Right: the Fan Dancer *was a 1920s figure in gilt, patinated bronze and ivory by Demêtre Chiparus*

produced in different sizes and materials in order to accommodate a wide retail price range.

Although Chiparus concentrated mainly on the posture of his model and the intricate finish applied to the bronze work, in Berlin the craftsmen were more concerned with the quality of the ivory carving. Their detailing in this was facilitated to a large degree by their adaptation of the pantograph (originally invented by Christophe Scheiner *c*.1605). This made it possible to maintain the proportions of the original and to duplicate accurately the carved ivory detailing, as they assembled the figures like jigsaw puzzles along a central core pin.

The German-produced figures also required less modelling to the costumes, as emphasis was provided by soft cold-painted metallic lacquers which were often shaded to provide contrast and to give depth.

Other eminent practitioners included the Belgian sculptress Claire-Jeanne-Roberte Colinet, who worked in Paris in a style similar to that of Chiparus. She also concentrated on similar subject matter, exotic figures and dancers, but associated with particular countries rather than with popular theatre and cabaret, for example. Her style was also more fluid, and her gilt and cold-painted work, such as the Hindu dancer and the Ankara dancer (*shown on the cover*) were recognisable by their flowing and detailed costumes which gave a sense of movement to the models' dramatic poses.

Viennese sculptors developed their own style of bronze and ivory statuettes and small decorative bronzes, drawing on both the Berlin and Paris styles. They combined the scale and surface treatment of the German workshops with the more theatrical French poses.

Bronze *animaliers* in the early twentieth century, such as the Italian sculptor Rembrandt Bugatti and the Belgian Alberic Collin, led the movement towards a more impressionistic portrayal of their subjects. Meanwhile, the French developed the stylized hard-line form and streamlined simplification that is now associated with Deco *animalier* sculpture, and which may best be appreciated in the work of François Pompon.

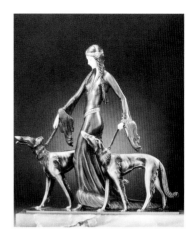

Above: The Aristocrats, *a bronze and ivory group by Otto Poertzel*

CERAMICS

Art Deco ceramics are to be found in a wide variety of designs and wares. The style of decoration ranges from rigid geometrical forms through stylized floral designs to great splurges of bright colour. These designs were the work of the artist-potters, the traditional manufacturers, and the industrial ceramicists alike, and might be applied to anything, from irregularly-shaped vessels such as cups with impractically formed triangular handles, right through to humorous or sensuous figurines.

Studio potters had complete responsibility for the design, modelling and glazing of their own wares. During the decade that followed the end of the First World War in France, a very high degree of technical virtuosity was achieved, with the mastery of glazing techniques becoming paramount. Unfortunately, this emphasis came at the expense of artistic innovation.

A few important and influential French potters did emerge during this period, and included André Metthey. He worked in both stoneware and faience, and used conventional Near-Eastern motifs, though he also invited prominent artists from the École de Paris to decorate his wares. However, from a technical standpoint, Émile Decoeur was the most significant artist-potter of the period in Paris. His work, initially in exquisite *flambé* glazes and incised decoration with rich layers of coloured slip, later developed in style towards monochromatic glazes.

Among the other prominent French artists were Émile Lenoble, distinguished by his stylized decorations; George Serré, known for his massive vessels, incised with simple geometric motifs; Henri-Paul Beyer, who revived salt-glazed stoneware; and Edmond Lachenal, who used a technique in which the glaze was made to

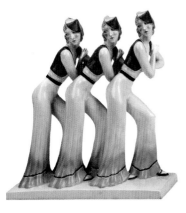

Above: a typical 1930s pottery group by Goebel and Hutchenreuther, an Austrian company which concentrated on figurines

resemble the geometric precision of cloisonné enamel, and a range of colours that included a brilliant turquoise blue that he liked to impose on a crackled ivory or beige ground.

Studio potters in Britain were hugely influenced by the ceramic arts of the Far East. Bernard Leach, born in Hong Kong and apprenticed to a Japanese potter, practised in the UK and unmistakeably showed these influences in his craft, which he taught to his student Michael Cardew. The latter turned more towards slip-decorated wares, influenced by the folk potters of central Africa. Katherine Pleydell-Bouverie was another Leach student, and from 1928 to 1936 she worked in partnership with Norah Braden, experimenting with glaze effects obtained from wood and plant ash.

American studio pottery in the 1920s and 1930s was largely influenced by the ceramics produced by the Viennese potters such as Valerie Wieselthier, who worked in a highly idiosyncratic style that involved bright, discordant, drip-glaze effects. The Wiener Werkstätte potters, including Wieselthier, participated in the International Exhibition of Ceramic Art which toured America in 1928. This resulted in the potter emigrating there, where she established the Sebring Pottery in Ohio.

Also in Ohio was the Cowan Pottery, the stock in trade of which included sleek Art Deco figurines. Waylande Gregory was its leading designer during the 1930s, but his best work appeared after the Cowan Pottery closed. By this time, his style had developed a more sensuous approach, with forms in a biscuit colour or washed in a monochrome glaze.

Other notable ceramicists practising in America included the painter Carl Waters, who had turned to ceramics in 1919. He had a strong modelling technique, and produced animal figures in limited editions. Wilhelm Hunt Diederich was another who also liked reproducing animal silhouettes, and Henry Varnum Poor, who had studied in both London and Paris, in America produced mostly simple tableware relying on the decorative value of slip and *sgraffito* for his desired effect.

Below: an extremely large decorated earthenware vase, created c.1925 by Boch Frères. It stands 1.63m (5ft 4in) high

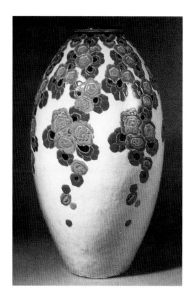

Above and top right: tea pots by Clarice Cliff, who made many such vessels in a complete range, from traditional to revolutionary. Her new approach to the ceramic arts was typical of English Art Deco

Below: a 35.5cm (14in) vase, c.1925, by Primavera

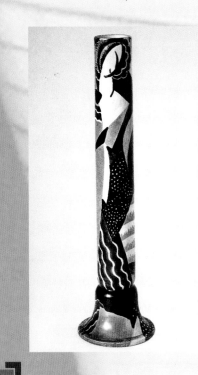

There was little to applaud during the period from the European state pottery manufacturers in either France or Germany, as neither was interested in promoting the Modernist aesthetic. The idiom was better served by the independent manufacturers, such as the French company of Haviland et Cie. This company's range of stylish tablewares was commissioned from distinguished artists that included Suzanne Lalique, Raoul Dufy, Jean Luce and Édouard M Sandoz.

It was during this time that the leading Parisian department stores founded their own design studios, and this meant that they needed household ceramics of every type for their new clientèle. This provided the opportunity for artists, who might not necessarily previously have been involved in ceramics, to design wares that were complementary to the furniture and furnishings that were the central items of their interior designs. In the case of the Pomone's Primavera studio, these exponents included Madeleine Sougez, Marcel Renard and Claude Lévy; while at Galeries Lafayette's La Maîtrise studio, Jacques and Jean Adnet and Bonifas were actively involved in supplying such design services.

Elsewhere in Europe, the modern style was vigorously adopted by the Belgian firm of Keramis, which was owned by Boch Frères. It produced a range that was similar in finish and effect to that of Edmond Lachenal's work, and which was sold to Primavera.

Gio Ponti produced in Italy a range of delicate ceramic forms, with strictly modern decoration that included geometric shapes and sporting scenes, for the Società Ceramica Richard-Ginori factory.

British artists were remarkably reluctant to become directly involved in transposing the modern decorative idiom onto manufactured wares, although there were notable exceptions. Susie Cooper, who was initially a decorator of blanks at A E Gray & Co Ltd, accepted an offer from the Crown Works to execute shapes of her own design. She went on to produce a great many tableware designs that were decorated with subdued abstract or geometric 'jazz style' patterns.

Clarice Cliff likewise created what were then thought to be outrageous tablewares, which were produced by Newport Pottery and are now regarded as icons of the decorative exuberance of the Art Deco style. Cliff used colour, geometry and bizarre shapes to create a range of novelty items and editions with fanciful names, all of which were retailed at astonishingly reasonable prices.

When the Weimar Bauhaus established its principle of functional form after the war, it became evident that a new approach to the applied arts would ensue. Its ceramicists, labouring in their workshops at Dornburg because there were neither adequate facilities nor space in which to build them at Weimar, wholeheartedly rejected tradition to create pieces of great artistic merit. However, the only German manufactory to show any interest at all in the Bauhaus's functionalism was the Staatliche-Porzellanfabrik, Berlin, which employed the Bauhaus pupil Margarete Friedländer-Wildenhain. Her mass-produced *Halle* service, 1930, sold alongside Trude Petri's *Urbino* service. The latter, which relied upon neither colour nor ornament for its success, was to remain in production for about 40 years.

Keith Murray was another designer who, working for Wedgwood, produced successfully for the European market an extensive range of non-derivative shapes, ornamented only by turned or fluted motifs.

It was the Americans who really knew how to exploit the mass-production market, and thus they were able to obtain phenomenal sales for their wares. These bestsellers included Frederick H Rhead's 1936 *Fiesta* range, which was designed for the Homer Laughlin Company. Although it was of simple geometric shapes, and only ever offered in five bright colours, it still managed to remain in production for over 30 years.

Finally, there was another very successful American-designed dinner service, Russel Wright's *American Modern*. Despite not having been designed until 1937, once the Steubenville Pottery had introduced it, it was able to keep it in production for 20 years, well after the Art Deco style had become *passé*.

Background: *a detail from a Clarice Cliff vase*

Below: *a Susie Cooper vase of 1928; 22.86cm (9in) high, it is painted in enamels*

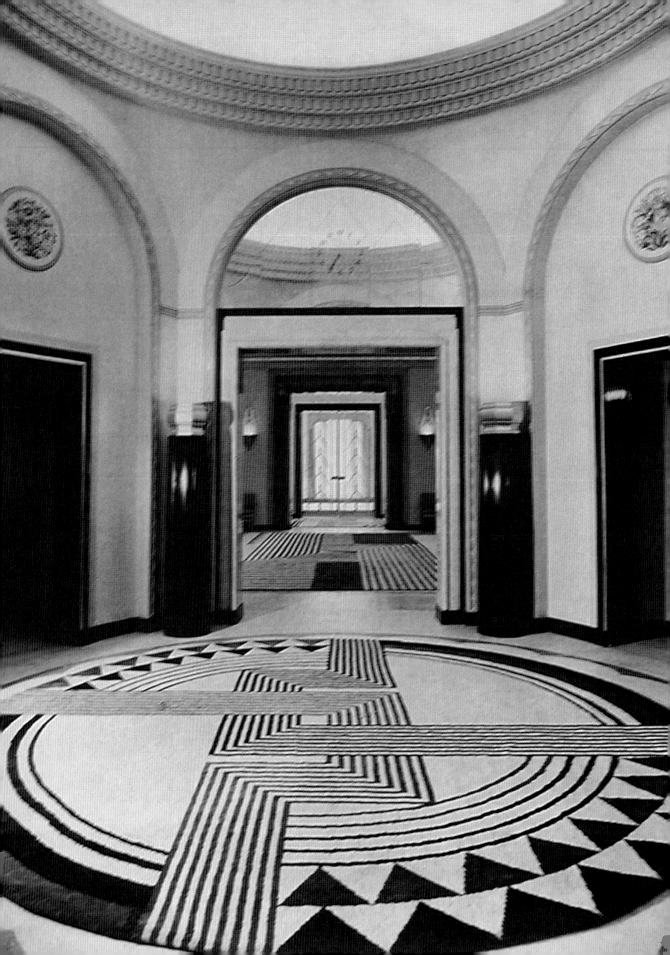

FURNITURE & INTERIOR DESIGN

FURNITURE IS WITHOUT QUESTION one of the most interesting and inspired applications of the Art Deco style. When coupled with the now virtually lost craft of the cabinet-maker, which has been usurped by mass-production methods, the originals of the 1920s and 1930s are now almost exclusively only museum pieces, although they remain influential even today.

The traditional skills such as marquetry and even French polishing, which I was fortunate enough to be taught as a boy, are all but gone; Art Deco furniture thus may be regarded as the final chapter in the craft of cabinet-making. To some extent the style may even have hastened its downfall, because Art Deco furniture design was split between two distinct trends. Following one path were the truly gifted master-woodworking entrepreneurs such as Ruhlmann, while working in parallel alongside them were the exponents of modern furniture, who experimented with metals and plastics in forms which lent themselves to mass production.

Left: the dome-topped yellow-painted vestibule of Claridge's Hotel, London, which was refurbished in 1929-30. The carpet was designed by Marion Dorn, who also designed the carpet in the reception area which lies beyond

Above: this lacquer table by Jean Dunand, of 1925, is 70 x 70 cm (27.6 x 27.6in) in size. The inlaid design is in crushed eggshell

Below: in the end, it was inevitable that mass-production should win the day. This chrome tubular-steel cantilevered chair was produced by PEL in 1936

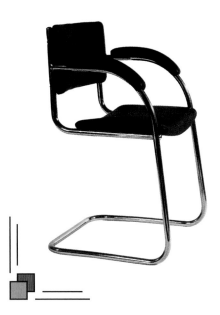

Ruhlmann, Süe et Mare, Jean Dunand and others had been taught to design furniture in the the Louis XVI or Empire styles; these were solid but not modern. As the designers' skills developed, they re-evaluated the styles, taking the best and then making subtle changes, along with using alternative materials and different finishes.

They enjoyed working in exotic materials, such as abalone, amboina wood, burr walnut, ivory, macassar ebony, mother-of-pearl, palmwood, tortoiseshell, silver and gold, which they incised, inlaid and lacqured.

The craftsman workshops were also fortunate, in that not only were they able easily to obtain these expensive, exotic materials in which to work, but they also had an outlet which hitherto had not existed, through the design studios of the major Parisian department stores. The customers of Au Printemps, La Louvre, Au Bon Marché and Galeries Lafayette could now obtain the most modern furniture at reasonable prices via Atelier Primavera, Studium-Louvre, Pomone and La Maîtrise. So it was that the *crème de la crème* of such young French designers as Louis Sognot, René Prou, Robert Block and Etienne Kohlmann, were brought in to direct the furniture production of these studios.

Many smaller firms had followed in the footsteps of these big four, and thus the quality and style of furniture benefitted from the competition; something that was very evident at the 1925 Paris Exposition, at which both the stores and the firms presented a spectacular show of ultra-modern household furnishings.

By the 1920s Armand-Albert Rateau was producing furniture that was among the most individualistic and sculptural of the time, and he, like others, embellished and sometimes even entirely covered furniture in exotic materials. However, the greatest cabinet-maker of Art Deco France was Émile-Jacques Ruhlmann, whose pieces were invariably sleekly moden in both decoration and detail. He used costly warm woods such as amaranth, amboina and ebony with which to veneer his desks and cabinets, which he inlaid with ivory. Later in his career he also used chrome and silvered metal.

Ruhlmann's L'Hôtel d'un Collectionneur at the 1925 Paris Exposition displayed his talent as an *ensemblier*. First he produced watercolour plans of the individual rooms for this imaginary town house of a wealthy connoisseur, and then he designed many of the individual items such as the rugs, fabrics, wallpapers, and pieces of porcelain with which to furnish them.

The other most notable artisans to emerge in Paris at that time included Jean Dunand, who designed and decorated elaborate furniture, but who is best known for his *dinanderie* and for his lacquerwork. His pieces, which were often covered with animal designs, include a superb black-lacquer cabinet which was exhibited at the 1925 Paris Exposition, and which had been designed by the ubiquitous Ruhlmann. Other pieces, such as his huge screens, displayed massive geometric motifs or elaborate mythological scenes. Dunand also contributed pieces for two ocean-going liners, the *Ile de France* and *Normandie*, but his best-known work, and the one single piece for which he will always be best remembered, is the bed which he made in 1930 for Mme Bertholet.

Below: Dunand's bed with lacquerwork and mother-of-pearl, 1930, was made for Mme Berthelot. The lavish gloss and vibrant colours he had seen in Japanese wares were perceived by Dunand as an ideal embellishment, and so he had transferred to lacquerwork in 1909, and became associated with the Japanese master Sougawara in 1912

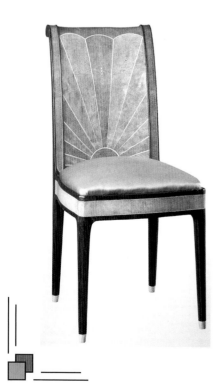

Above: this bed, which dates from the 1930s, was designed by Arbus and has a lacquer finish by Jean Dunand. The feet of the bed are in shagreen
Above right: Ruhlmann's striking 'sun' bed exploits the grain of the ebony-veneered headboard

Another among the many eminent practising and accomplished Parisian furniture designers and *ensembliers* was the Irish-born architect Eileen Gray. From the outset she fashioned handmade items of the highest quality, including screens, tables and, most notably, chairs. She also made much use of Japanese lacquer, the technique that she had learnt from Sougawara, as indeed had Dunand. As Gray matured, so her work moved forward into a more rectilinear and strongly functional furniture style, which then was vastly different to that of Pierre Legrain.

Legrain had made his mark as a designer of book bindings for Jacques Doucet, but like many of the other Art Deco artists in Paris at the time he was able to apply himself with equal success to other media. Much of Legrain's work included African influences, and he liked to work in the exotic materials, especially in mother-of-pearl, which was featured whenever possible.

The real masters of the new Deco materials such as rare woods, ivory and enamel were Clément Rousseau and Adolphe Chanaux. Rousseau executed finely-detailed furniture, and is best known for the chairs for which he favoured working in rosewood and shagreen; Chanaux, for his absolute mastery of marquetry.

There was little, if anything, of quality in the Art Deco style in Great Britain during the period. Ambrose Heal and Practical Equipment Limited (PEL) did produce some functionalist furniture with distinctly modern lines, as did Betty Joel, whose firm won many commissions, and who is remembered today primarily for an inexpensive range of furniture which she intended for the working woman.

This was quite at odds with the prevailing conditions in Germany, where designers concentrated on making expensive custom-made limited-edition furniture, but for which they emphasized simplicity of design, with inlaid veneers. Likewise in the Netherlands, where Gerrit Thomas Rietveld created the now famous red-blue chair, in 1918: this exemplified the *de Stijl* aesthetic of simple geometric shapes, primary colours, and horizontal and vertical lines.

In 1926 a loan exhibition of items from the previous year's Paris Exposition toured American cities. The net result was that the New York-based Company of Master-Craftsmen produced blatant copies of the French furniture pieces, complete with marquetry panels and inlays. This somewhat shameless activity succeeded only in distracting attention away from some very original and dramatically modern pieces of furniture, that were being designed and produced right the way across America. Craftsmen there were already producing items of classical proportions, which they adorned with mother-of-pearl inlays, as early as 1920.

Among the leading exponents of American Art Deco furniture design were Paul Frankl, who designed highly individualistic 'skyscraper' bookcases, and cabinets with stepped sections. The skyscraper theme was also exploited by Kem Weber and J B Peters, both of whom were working at the time in Los Angeles as designers, and the Chicago-based Abel Faidy, who produced some rather whimsical pieces for private clients, derived from architectural themes.

Weber, who was German by birth, was not the only emigré designer in America of the 1920s and 1930s. Eliel Saarinen, Eugene Schoen, Wolfgang Hoffmann, Gilbert

Far left, bottom: an ebony chair of the mid-1920s by Clément Rousseau, who used shagreen with ivory inlays for the chair back
Below: designed in the idiom of the Manhattan skyscrapers, this chair by Faidy was created in 1927, predating the New York districts' classics such as the Chrysler Building, 1928–29, and the Empire State Building, 1931

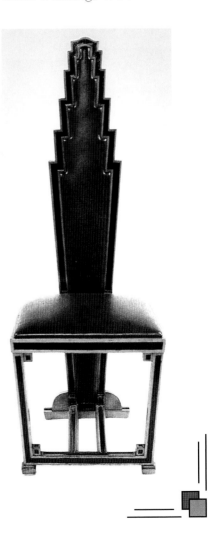

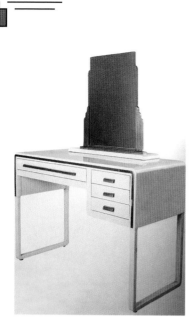

Above: dressing table in enamel on metal, 1929–32, by Norman Bel Geddes
Below: Yasuo Kuniyoshi designed the ladies' powder room at Radio City Music Hall. He was just one among the creators of its internal and external decoration

Rohde and Joseph Urban were also plying their trade to create beautifully original furniture for the American market. Although most of their pieces were mass-produced, they drew on American materials.

Much of the new Deco-styled wooden furniture was therefore built in the state of Michigan, by companies such as Berkey & Gay, Johnson-Handley-Johnson, Imperial Furniture, Herman Miller and the Ypsilanti Reed furniture company. It was designed by the foremost artisans of the period, who included Ely Jacques Khan and Norman Bel Geddes. Meanwhile, Donald Deskey was emerging as the leading designer of metal furniture, though many others, including Gilbert Rohde and Dorwin Teagre, also produced inspired pieces of metal furniture which had clearly become the preferred and accepted medium for the majority of American buyers, by the end of the 1930s.

Deskey was not interested only in designing individual pieces. He preferred to be employed in the creation of a whole room or suite; or, better still, an entire building. He was following a relatively well-established ethos, in which furniture designers and architects had attempted to design every element of the interior to ensure cohesion and unity. However, the newly-apparent role of an *ensemblier* was not established until 1911. Evidence of particular interior decorators' collaboration on certain commissions had been apparent in the salons before 1925, but at the Paris Exposition the entire membership of the Société des Artistes Décorateurs cooperated to create one of the event's major successes, L'Ambassade Française.

The unquestioned champion, and the first patron of the new style, was the couturier Jacques Doucet, who employed the services of the most *avant-garde* artist-designers in Paris, including Paul Iribe and Pierre Legrain, to design his house in Neuilly, France.

Other notable successes of large-scale cooperation were the French embassies in Warsaw and Washington, the Parfumerie D'Orsay, and the luxury liners such as the *Normandie*. In truth, the elegance and opulence

Right: Ruhlmann's pochoir illustration of the bedroom designed for Baronne Henri de Rothschild, 1924, showing the dark-veneered and ivory-inlaid furniture

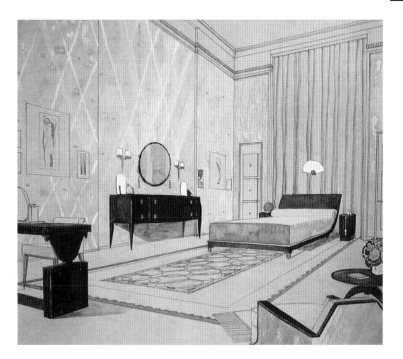

of Parisian Art Deco was best expressed in the interiors which were the product of collaboration between furniture and textile designers, sculptors, painters, ceramicists and various other hugely talented artisans.

Synonymous with the nomenclature of *ensemblier* were such entrepreneurial artists as Ruhlmann, Mallet-Stevens, Jourdain, Gray and the team of Süe and Mare.

Right: the furniture maker Jules Leleu had his own stand at the 1925 Paris Exposition. Situated on the Esplanade des Invalides, it included this dining room, with furniture designed by him complemented with carpets and rugs by Bruno Da Silva Bruhns. The latter's designs were yet to develop into a more distinctive modernistic style

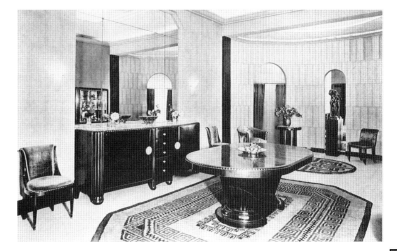

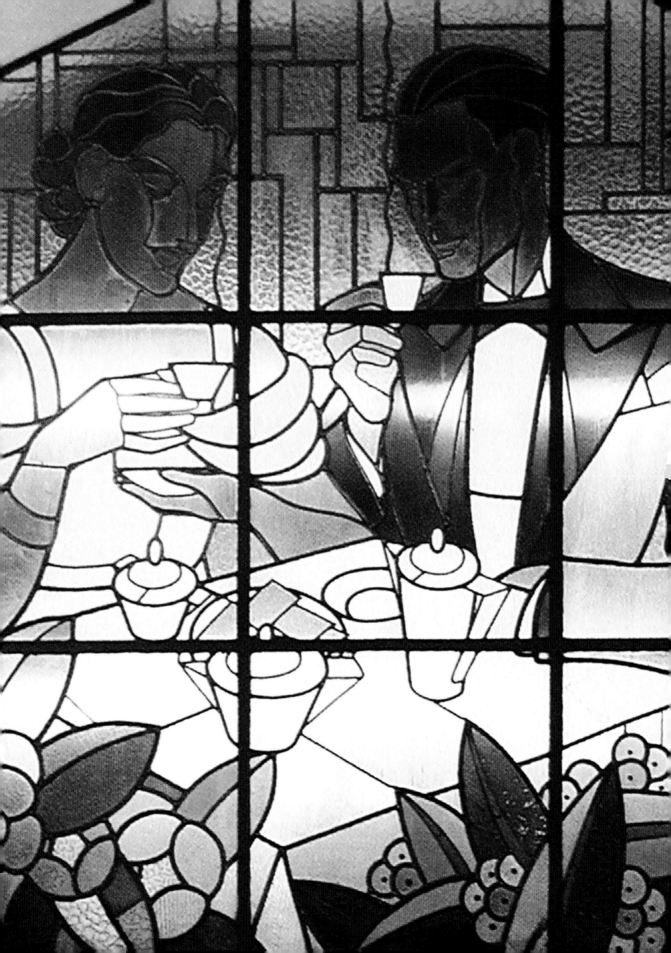

GLASSWARE & LIGHTING

GLASS WORK OF THE ERA is most commonly associated with the output of its two greatest exponents, René Lalique and Daum Frères, but in truth they are a very long way from representing the entire gamut of Art Deco glass production.

Newly-invented types of glass compound came into being, which allowed for a wider range of techniques and applications. Running parallel with these came a revival of many of the old techniques, and while René Lalique began to use moulds and casts in order to mass-produce his glass sculptures, Maurice Marinot had developed new methods which enabled him to trap bubbles between skins of glass in his vases. Elsewhere there was the refinement of both etching and engraving methods, and the revival of *pâte-de-verre* and *pâte-de-cristal* techniques, which aided the art of glass sculpting.

Lalique was without any question one of the major names and influences in Art Deco glass. He began working in glass in 1902, and by 1909 he was producing demi-cristal glass in his own factory. Most of his ornamental pieces were shaped initially in another material, from which he took a plaster cast. Glass was

Above: an enamelled glass vase by Goupy, 1921
Left: a section from a mid-1930s stained-glass panel, by Ricardo Leone

Below: a late-1920s scent bottle by Baccarat, who designed bottles for a number of parfumiers including d'Orsay, Jean Patou, Rimmel, Yardley, Elizabeth Arden, Coty, Roger & Gallet and Guerlain. At the 1925 Paris Exposition, the firm shared a pavilion with Christofle

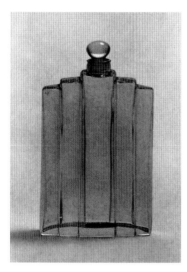

then poured into the mould made from the cast, which could be re-used for mass production.

Lalique's greatest asset was his ability to produce a staggeringly wide range of subjects that included everything from the sentimental neoclassical nude to his exceptional Art Deco coloured vases. Such was the success of his various forms, techniques and designs that his work acquired a great many disciples. These imitators, try as they might, were never quite able to replicate his peerless production methods, the secrets of which Lalique guarded passionately.

The other great French glass workers of the period included Maurice Marinot, a painter and a member of the expressive Fauve group. Between 1911 and 1937, he produced some 2,500 *objets d'art*; vases, jars and bottles. All of these were thick-walled and contained among their decorative elements, bubbles, specks of chemicals, deeply etched designs created in the acid bath and multi-layered pieces that contained a variety of colours and streaks within their layers.

Marinot, like Auguste Heiligenstein, Jean Luce and Marcel Goupy, also enjoyed decorating his work with colourful enamelled designs. Others, such as François-Émile Décorchement, became noted for their skills in the production of *pâte-de-cristal*, a technique which Décorchement had perfected before the First World War, producing some near-transparent vessels and thick-walled pieces which he normally decorated with stylized floral motifs. He also made extensive use of colour, as well as being able to produce heavy vessels resembling marble, by chemical streaking within the glass.

Décorchement's postwar style became ever bolder and more stylized. His refined mature style typically had rigid, often cuboid, forms, with relief geometrical decoration, and was to culminate in highly geometrical images. However, Décorchement was working almost exclusively on church window decoration by the end of the 1930s, and for this he used *pâte-de-verre* in order to create a richness and warmth.

Gabriel Argy-Rousseau was another who worked in

pâte-de-verre and *pâte-de-cristal* glass, producing smaller objects that included three-dimensional neoclassical figures. His work was as sculptural, but not as decorated, as that of Alméric Walter, who was employed as a glassworker by Daum Frères to produce an array of *pâte-de-verre* items.

In France, the long-established Baccarat and Émile Gallé had provided the foundation from which the new Art Deco master glassworkers had evolved. Meanwhile in Scandinavia, Orrefors had become established with a fresh and innovative style, utilising its Graal technique. This was a modification of the French Art Nouveau cameo technique that had been popularised by Gallé, and which involved superimposing layers of coloured glass, etched with relief decoration. From 1917 Simon Gate was their leading designer.

Hadelands Glassverk produced a range of glass for the table with restrained engraved decoration from the 1920s in Norway; in neighbouring Finland the best contemporary glass was the range of Savoy vases, clear coloured ware designed by the architect Alvar Aalto.

In the Low Countries of Europe the Belgian Val Saint-Lambert works produced a range called Arts Décoratifs de Paris, which had crystal bodies overlaid in patterned transparent coloured layers. In the Netherlands, the Royal Dutch glassworks commissioned Hendrik Berlage to design tableware items for mass production.

The Wiener Werkstätte produced possibly its best glassware prior to the 1925 Paris Exposition. Examples were typically decanters, which were made by the Lobmeyr factory. The greatest influence on American glassware, though, came about as a result of the breakup of the German Bauhaus and the emigration of its leading designers to the USA.

Steuben introduced a new range of glassware in the 1920s, in the French high Art Deco style. Frederick Carder was initially responsible for many of the designs in this range, examples of which might be characterised by their decorative use of zigzags, stylized gazelles or curved outlines.

Above: in the early part of the twentieth century, Tiffany & Co dominated glass in America but as the Deco style emerged, it was influenced initially by the work of the Bauhaus and of the Werkstätte. However, the Depression caused the abandonment of production of such exclusive designer pieces as this Steuben vase, in favour of mass-produced press-moulded ware for which the streamlined style predominated. These were typically pale or pastel-coloured pieces, which eventually became known as examples of Depression glass

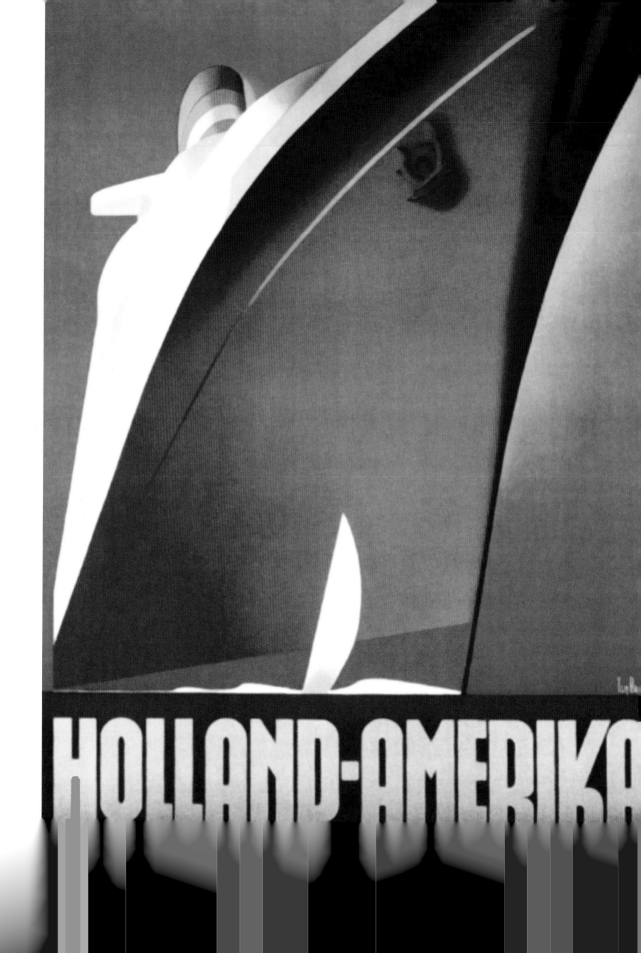

THE GRAPHIC ARTS

THE TRUE ORIGINS OF THE POSTER lie in the stained-glass windows of the world's cathedrals; brightly coloured, full of images and messages, they were designed to tell a story and get their message across to the masses. By the twentieth century, it was the striking design of the cheaply-produced poster that was aimed at catching the attention of the casual passer-by.

The art of design for advertising media in the form of the poster had breached boundaries, in terms both of the artists' understanding of its constraints, and of the marketeers' appreciation of it as a sales aid. The skills learnt by creative artists such as Henri de Toulouse-Lautrec were now being applied to promote a host of new products by a generation of 'commercial artists', who were employed by the new advertising agencies.

Their messages were conveyed in simple lines, bold colours and striking typography, influenced by the growing impact of the machine, with power and speed becoming the primary selling themes, the buzzwords and imagery of the prosperity of the postwar years.

The Art Deco poster was thus the first full-blown example of a sophisticated approach, in a new

Above: one of many covers for Vogue *magazine by fashion illustrator Georges Lepape, in the 1920s*

Left: a poster for Holland-Amerika Lijn, designed in 1936 by Willem ten Broek

Right: two posters by the leading artist Adolphe J M Cassandre. His many distinctive works are in a graphic style which utilised bright colours combined with subtle shading to create a sense of speed or a metallic appearance. The Cook's Wagons Lits poster, **left**, was produced in 1933; **right**, that for the Normandie had been drawn originally in 1935 but continued to appear until 1939 with different strap lines, and remains the enduring modernist vision of the ocean-going liner

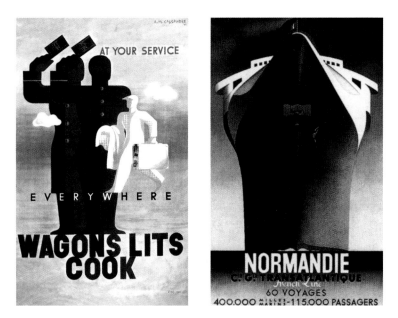

Below: a poster designed by Plinio Codognato and produced in-house by the advertising department of Fiat, then Europe's largest car factory, in 1927

consumer age, to the promotion of leisure pursuits such as travel, art exhibitions and sporting events. Although unsurprisingly the most striking images of the period are by French artists, the first of the century's sans-serif typefaces, Railway, had been designed in 1918 by Edward Johnson for the London Underground system. This face contrasts with the Universal typeface, designed in 1925 by the Bauhaus typographer Herbert Bayer, also devoid of serifs and other decorative elements.

Universal itself may be contrasted with Adolphe J M Cassandre's Bifar face of 1929, which consisted of letters that were barely recognisable except for their grey areas. Cassandre was perhaps the most innovative of the new French artists, relying upon the striking images and strong colours which he combined with an unusual sense of perspective. His best-known works are his travel posters for the Nord Express railway service of 1927, and for the ocean liner *Normandie*, of 1935.

However, if Cassandre's is the name most closely associated with Art Deco transportation posters, then that of Paul Colin is the most important in the area of theatre advertising. Most memorable are those advertising the actress Josephine Baker, often portrayed

Right: this exuberant stylized dancer adorns in bas-relief a central position on the façade of the Folies-Bergères. It was by Picot, and echoed the style of representation on posters of the artistes performing there at the time

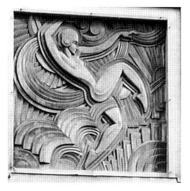

in a lighthearted illustrative style. Colin's other poster designs also mostly feature human figures, sometimes highly stylized, sometimes lovingly caricatured. They included advertisements for black jazz musicians who were performing at the Casino de Paris, the Music Hall des Champs Elysées, and the Folies Bergères, and these subjects provided the name of the Jazz Style.

Another of the popular cabaret performers to feature frequently on posters of the Deco period was Mistinguett (1875–1956), who was presented in a more curvilinear and ornate style by the artist Charles Gesmar. He was responsible for the design of some fifty posters during the course of a short career.

Of the numerous other active graphic artists of the period, the outstanding contributions made by Charles Loupot and Robert Bofils, both of whom produced posters for the 1925 Paris Exposition, should also be accorded recognition. René Vincent (Au Bon Marché) and Jean Dupas (Saks of Fifth Avenue) designed for leading department stores, while the world of fashion was very well served by leading talents such as Georges Lepape and Natalia Goncharova.

Outside France, the American-born Edward McKnight Kauffer worked for both London Transport and the Shell Oil company, while the Swiss-born Léo Marfurt's Les Créations Publicitaires produced posters for the *Flying Scotsman*. Dutch shipping lines countered the work of Cassandre with posters by Willem Frederik ten Broek and Kees van der Laan.

PRINTING METHODS

Both printing techniques and the processes of colour reproduction had recently improved vastly, and the finished article could be produced to a very high quality, in a number of different ways.

Engravings and etchings: craft techniques on copper plate. An engraving was made by means of of a burin, a gouging tool with a scoop-like blade, drawing directly on the plate. Varying the pressure as the blade moved thus resulted in a thicker or thinner line, to show the direction of light falling on the object being drawn and so indicate a perspective. In etching, the plate is covered with wax, the design drawn onto it and then the plate is dipped into acid which eats into areas not still covered by wax. This gives a cleaner line, with no burr (waste metal) to remain along the edges of the lines as in engraving, and the resistance of the wax may be varied to add texture or tone to areas of the image.

Lithograph: wax, or an ink-resistant chemical, is applied to the non-printing areas of the stone surface. This is then washed with ink, covering only exposed areas to print from.

Photogravure: a commercial process; the original drawing is photographed. Its negative is exposed on a light-sensitive copper plate. The image is then acid-etched to form tiny cells on the plate that hold the ink, giving subtle tones.

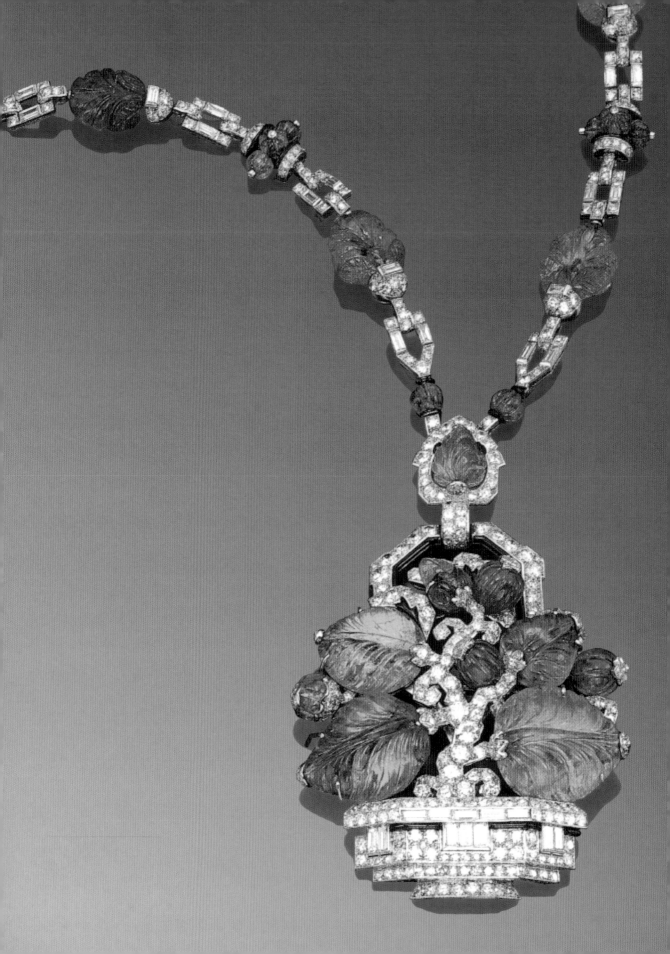

JEWELLERY

DURING WHAT WE NOW KNOW as the Art Deco period, a multiplicity of extremely varied items was produced in an extraordinary range of categories. Craft skills were most cost-effectively deployed in conjuction with expensive materials, and so not only was jewellery included, but by its nature proved durable.

The great French goldsmiths used costly minerals for the production of their miniature works, which took on starkly geometric forms or reflected other influences such as the Egyptian and oriental, or were wildly florid, be they in platinum, now increasingly available, highly versatile and very durable, gold or silver, or such opaque stones as onyx, turquoise, jade or lapis lazuli.

The major jewellers of the day, which included Boucheron, Cartier, Chaumet, Fouquet, Lacloche Frères, Mauboussin and Van Cleef & Arpels, produced and promoted everything for the rich and fashion-concious

Left: an enamel, emerald and diamond sautoir with a detachable pendant, c.1930, by Mauboussin

Below: a diamond, ruby, emerald and sapphire bracelet by Lacloche Frères, inspired by the discovery in 1922 in Egypt of Tutankhamen's tomb

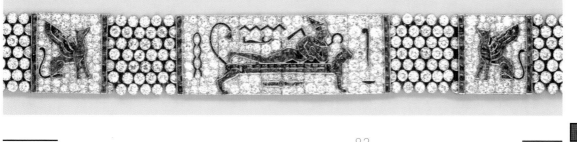

Below left: an oval brooch, designed for Boucheron in platinum, onyx and coral with diamonds by Charles Massé, that was originally exhibited at the 1925 Paris Exposition

Below right: a silver and black enamel brooch by Raymond Templier, who was a founder member of the Union des Artistes Modernes

Bottom: an enamelled metal powder compact of the 1930s

female: brooches, bracelets and bangles, earrings and ear clips, watches and powder compacts, and the latest must-have cigarette cases. After all, women might now smoke in public, since a sort of recklessness had swept across Europe to liberate its peoples from the horrors of war. The impact of this heady 'anything goes' attitude characterised this period of social history. Women considered that they had earned the right not to return to their traditionally passive roles, but to retain their self-reliance. Now they wanted to dance the night away, drink cocktails, smoke cigarettes and drive fast cars.

As their dresses became increasingly streamlined, they were fashioned in lighter materials. The backs and the necklines were cut lower and sleeves disappeared; similarly hairstyles became shorter, and so jewellers were put to task to produce complementary pieces.

The taste of these newly-liberated and independent women, at the luxury end of the market, was well catered for by the established jewellers who used these boldly-coloured opaque stones. As ever, their demands were echoed by the less well off, who also had aspirations to be fashionably turned out, and were not prepared to allow their desires to be thwarted.

Thus began the great era of of mass-produced costume jewellery. Not only did the glass jewellery promoted by Lalique and his imitators become

increasingly popular, but also manufacturing methods had developed of painting designs onto base metals to simulate enamel inlays on precious metals.

The cheaper designs also made use of the new plastics, while both diamanté and marcasite were frequently used. So it was that when such famous artists as Jean Dunand designed brooches, earrings and bracelets embellished with geometric designs in black, red and gold lacquer, these were easily imitated. It was almost inevitable that the Art Deco period should spawn thousands of cheap anonymous designs, mostly made in Bakelite, celluloid and other synthetics.

Mass-produced powder compacts and vanity cases were hugely popular, especially in America. Those produced by the industrial metal manufacturer Elgin American mostly retailed at less than one dollar each.

Below: a costume jewellery set comprising a brooch, necklace and earrings, in a Cubist design; **below left,** a glass medallion pendant on a black silk cord with seed pearls by Lalique. Bold designs, that were inspired by both contemporary artists and the cultures of distant and ancient countries, were now perfect adornments for the wrist, neck and ears of the socially liberated Art Deco woman

A colossal amount of jewellery was now being produced, at least partly as a result of the sweeping changes in women's dress. For example, as hair styles became shorter, earrings became longer; brooches, previously adorning only evening gowns, were now also worn on coat collars out of doors; bare arms required bracelets, which could be worn either on the wrist or high up on the newly bared arm, whether singly, in graduated clusters or as flat broad bands. The lady's wristwatch was growing in popularity, especially those with silver or platinum faces inset with geometric initials or paste stones. The lower necklines required initially rows of pearls, which were to evolve into strings of carved beads such as jade, agate or coral.

Thus the jewellery of Art Deco was both opulent and extravagant, matching the sense of *joie de vivre* and freedom that women enjoyed after the First World War.

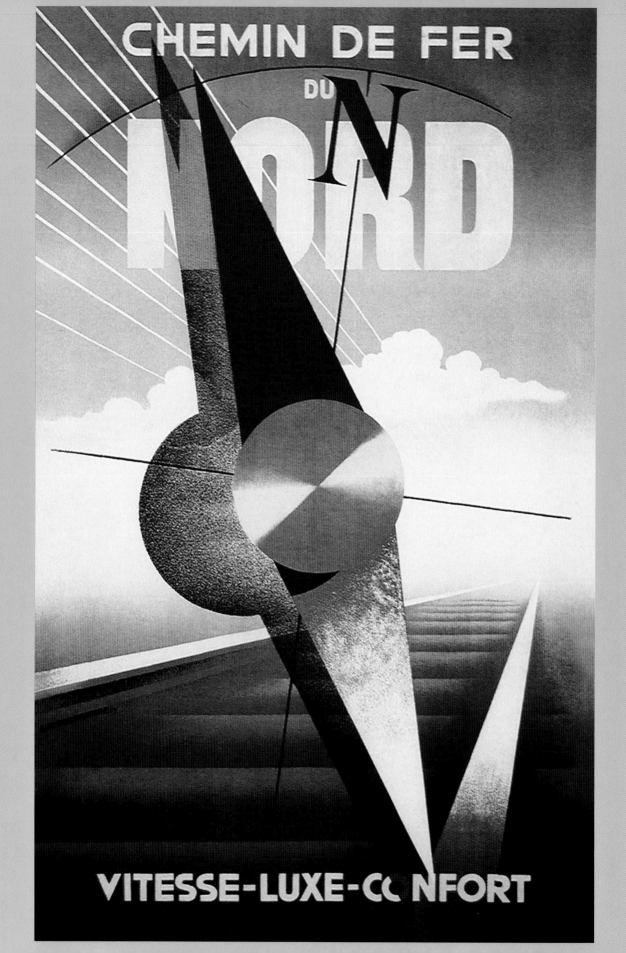

THE ARTISANS

Aalto, Hugo Alvar Hendrik (1898–1976)
Finnish architect and designer

Educated at the Polytechnic of Helsinki, 1916–21, he practised in Jyväskylä from 1923, in a typically Scandinavian national romantic idiom derived from the works of Lars Sonck and Eliel Saarinen combined with the Nordic classicism of Gunnar Erik Asplund. His first major design in a decisively modernist style was his Turam Sanomat building. He was joined in practice by his wife, Aino, in 1925; became a CIAM member in 1928, and invented bent plywood furniture in 1932. He returned to Helsinki in 1933, and in 1935 formed the Artek furniture company with his wife, Harry and Maire Gullichson, and Nils Gustav Hahl. From 1940 he was professor of architecture at the Massachusetts Institute of Technology, in Cambridge, Massachusetts. His major works include the tuberculosis sanatorium, Paimio, Finland, 1929–33; municipal library, Viipuri, Finland, 1930–35 and Finnish pavilions for the World's Fairs in Paris, 1937, and New York, 1939

Below: an armchair constructed by Alvar Aalto in laminated birch and veneered plywood for the tuberculosis sanatorium at Paimio

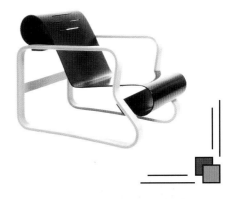

Left: this lithograph by Adolphe J M Cassandre, Chemin de Fer du Nord, of 1929, typifies the speed as well as the style of modern life, and contemporary reverence for ever-faster communications

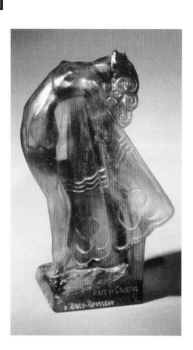

Above: a typical pâte-de-crystal *draped figure that was produced in about 1930 by Gabriel Argy-Rousseau*

Below: Baccarat's liqueur set with black enamel sun-burst decoration on the decanter, of the 1920s

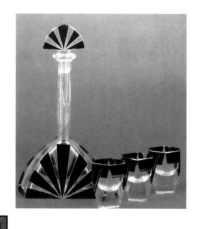

Argy-Rousseau, Gabriel (1885–1953)
French glassmaker and ceramicist
Born in Paris as Joseph-Gabriel Rousseau, he entered the National High School for Ceramics at Sèvres in 1902. He first exhibited his *pâte-de-verre* in 1914 as Argy-Rousseau, having adopted his wife's family name the previous year. From 1919 onwards he made a series of enamelled scent bottles, and entered into a partnership with Gustave-Gaston Moser-Millot, who funded a workshop called Les Pâtes-de-verre d'Argy-Rousseau. In addition to scent bottles, Argy-Rousseau made vases, table lamps, bowls, jars, pendants, brooches and perfume-burners. He displayed at the 1925 Paris Exposition, and in 1928 he produced a group of *pâte-de-cristal* sculptures designed by Marcel Bouraine. The glassworks closed in 1931, after which Argy-Rousseau worked alone

Baccarat (founded in 1764)
French glassworks
During the 1920s and 1930s, the firm of Baccarat vied with René Lalique and Émile Gallé in creating the most exciting contributions to the skill of glass working. It produced a great number of bottles for the burgeoning perfume industry, its clients including among others the houses of d'Orsay, Jean Patou, Rimmel, Yardley, Elisabeth Arden, Coty and Guerlain. During this period its work was heavily influenced by the sculptor Georges Chevalier, with a great deal of emphasis being placed on enamelling, geometric motifs, and panel forms with sharp edges

Barbier, George (1882–1932)
French theatre designer, graphic and poster artist
A prolific and gifted artist, he was influenced by the *Ballets Russes*, and developed a similar graphic style for fashion illustrations, theatre sets, costume design, posters, advertising, and magazine covers, which are often in the form of *pochoir* prints. He illustrated many books on dance, in addition to costumes for the

Folies-Bergères and Casino de Paris. In the late 1920s he worked for a short time in Hollywood, while his finest prints were those produced as woodcuts by F L Schmied. His style displays a strong Japanese influence, his women are generally fuller-figured, and also more sensuous than those of Georges Lepape, while his backgrounds are usually in a plain colour

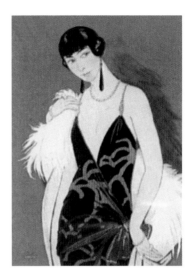

Bastard, Georges (1881–1939)
French dinandier
Born in Andeville, France, he was educated at the École des Arts Décoratifs, Paris, before beginning work in his father's atelier. There he worked producing *objets d'art*, such as ladies' fans, letter openers and small boxes. These items, often with carvings inspired by naturalistic forms, were in delicate materials which included rare woods, mother-of-pearl, ivory, tortoiseshell, and horn, in addition to semi-precious stones. He collaborated with Jacques-Émile Ruhlmann and Pierre-Paul Montagnac on several pieces that were displayed at the 1925 Paris Exposition. In 1938 he was appointed director of the Sèvres porcelain manufactory

Above: a 1922 fashion illustration in gouache by George Barbier entitled Elegante en robe du soir bleue

Below: scales, designed as a single unit in 1929 by Bel Geddes for the Toledo Scale Company

Bel Geddes, Norman (1893–1958)
American architect and industrial designer
Born in Michigan, he attended the Cleveland School of Art and the Art Institute of Chicago before joining the Chicago advertising agency Barnes-Crosby as a draughtsman. In 1918 he embarked upon a career as a stage-set designer in New York, only taking up industrial design in 1927 when he opened his own firm. He became one of the foremost practitioners of industrial design; in 1929, he produced both furniture for the Simmons company and counter scales for the Toledo Scale company, followed by a range of gas stoves for the Standard Gas Equipment Corporation, 1932, and a skyscraper cocktail shaker, 1937. His revolutionary ideas and products spread out to other disciplines, including architecture. His most spectacular success

was the General Motors' Highways and Horizons exhibition for the New York World Fair in 1939. Bel Geddes can be largely credited with creating the streamlined style which replaced the sharp angles of the 1920s with smooth, sleek, rounded forms suggestive of energy and movement. It was a style which was to permeate both interiors and exteriors of buildings, and which proved, perhaps, to be the most evident form of Art Deco in the United States. His designs followed closely the Bauhaus principles of integrating form with function and he discribed it as a treatment suitable for virtually any product

Above: *the streamlined Union Pacific diesel M-10000, City of Salina, was one of the first General Motors mainline locomotives, and was styled by Bel Geddes in 1935. It was installed in daily service between Kansas City and Salina*

Below: *a textile pattern from Édouard Bénédictus' Nouvelles Variations album. His books of coloured gouache plates were widely used by other Art Deco designers*

Bell, Vanessa (1879–1961)
British painter and decorative designer
Born in London, the elder sister of Virginia Woolf, she studied at the Royal Academy Schools, 1901–04. A leading member of the Bloomsbury Group, in 1907 she married the critic Clive Bell, leaving him in 1916 to live with Duncan Grant. Her work was strongly influenced by the style of the French post-impressionists, and together with Grant she contributed to the Omega Workshops from 1913. However, after its closure, in 1921, she worked on commissions from Clarice Cliff and the Arthur J Wilkinson & Co factory

Bénédictus, Édouard (1878–1930)
French tapestry and rug designer
Before turning to tapestry Bénédictus trained as both a painter, then a decorator. He contributed to the Sèvres pavilion for the 1925 Paris Exposition, and to the State-sponsored L'Ambassade Française, to which he contributed silk wall hangings for the salon with motifs of fountains and flowers. He later executed designs for Tassinari, Chatel, Brunet and Meunier & Co, while his vividly-coloured *pochoir* prints provided inspiration for many of Clarice Cliff's colour combinations, including her Appliqué range which was introduced in 1930, the year of Bénédictus' death

Blondat, Max (1879–1926)
French architect and sculptor
Blondat originally worked in the Art Nouveau style, but contributed to the interior design of the Sèvres pavilion for the 1925 Paris Exposition, for which he also designed two lunette-shaped reliefs for the dining room of the L'Ambassade Française. He was also responsible for many public works, such as fountains, memorials and tombs

Boch Frères, Keramis (founded in Sept-Fontaines, Belgium, in 1767 as Boch Frères)
The original company split in the mid-nineteenth century, with one part of the firm re-establishing itself as Boch Frères, Keramis. It produced mainly earthenware vases, tableware and candlesticks, and was the major Belgian contributor to Art Deco of white crackled glaze ware. Its important designers of the period were Charles Catteau and Arthur Finch

Bonet, Paul (1889–1971)
French bookbinder
He studied at the École Robert-Estienne under Desmules and Giraldon, and first exhibited in 1925 at the Exposition du Livre, Paris, the Salon d'Automne, and at the Société des Artistes Décorateurs. He went on to develop new photographic, collage and sculptural binding techniques, and pioneered the use of new materials. His major works include *La Belle Enfant* and *Colligrammes*

Above: the book binding design in ivory with black morocco inlays, blocked in gold with gilded edges and silk front endpaper, by Paul Bonet for Les frères Zemganno *by Edmond de Goncourt, Paris, 1921. The size of this limited edition of 200 copies was 28.5 x 20.4cm. The books were bound by R Gorce*

Bonfils, Robert (1886–1971)
French bookbinder, poster and graphic artist
Born in Paris, Bonfils was destined to become one of the most versatile Art Deco designers, being responsible for a wide range of works. He was one of the three artists commissioned to design the official posters for the 1925 Paris Exposition. In addition, he also designed the official catalogue cover and was appointed to the exhibition organising committee. He

was later to become one of the most important designers for the Sèvres porcelain factory, as well as for the fashion periodical *La Gazette du Bon Ton*, which was published in France between 1912 and 1925. He also produced many textile designs for the firm of Bianchini Férier

Boucheron, Frédéric *see* Maison Boucheron

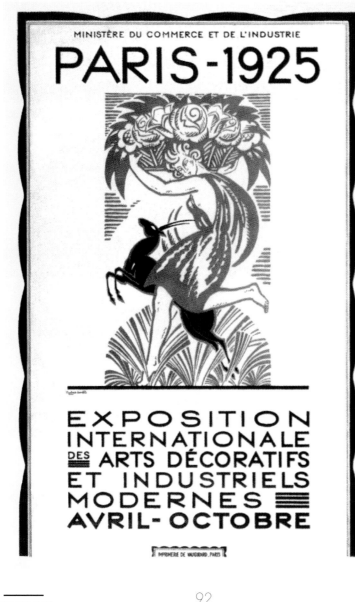

Left: one of the posters used to advertise the 1925 Paris Exposition. This one was designed by Robert Bonfils

Below: Robert Bonfils' work was to be found in no fewer than nine different classes at the 1925 Paris Exposition; this bold yet delicate book binding was designed at about the same time

Above: The Three Graces, *in gilded bronze, form the central panel of this screen in wrought iron, designed by Max Blondat with Edgar Brandt, c. 1923*

Bouraine, Marcel (d.1935)
French sculptor
Born in Pontoise, he was active between 1918 and 1935, and is best known for his chryselephantine figures and his cast-bronze female groups. His work, which was exhibited during the 1920s at the Salon des Artistes, the Salon d'Automne and the Tuileries, also included mythical and sporting figures

Brandt, Edgar (1880–1960)
French wrought-iron worker
Born in Paris where he opened his atelier in 1919, Brandt produced his own designs in addition to executing the work of others. He was a major contributor to the 1925 Paris Exposition, at which he had his own exhibition stand. In addition he made the iron gates for the Jacques-Émile Ruhlmann pavilion, L'Hôtel d'un Collectionneur, metal lampstands for the Daum glass factory, and gates for

Right: a lift door from Selfridges department store in Oxford Street, London by Edgar Brandt, 1927–28. The design was effected in wrought-iron and bronze

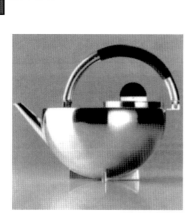

one of the main exposition entrances, La Porte d'Honneur. When he was commissioned to provide the ironwork for the Cheney Building, Madison Avenue, New York, 1926, he established Ferrobrandt Inc. to handle it, together with the many other commissions that soon followed. He was also responsible for the ramp for the Mollien staircase at the Louvre, the gate for the new French Embassy in Brussels, and the Eternal Flame for the Tomb of the Unknown Soldier, Paris

Brandt, Marianne (1893–1983)
German metalworker
Brandt is regarded by many as the most important silversmith of the Bauhaus, where she was a student from 1923 to 1928. During 1924 she worked with László Moholy-Nagy designing prototypes in a metal workshop for the industrial production of everyday objects. She worked with Walter Gropius from 1928 until 1929 on the Dammerstock housing project, after which she designed metal objects for Ruppleberg

Breuer, Marcel (1902–81)
Hungarian architect and furniture designer
Breuer was one of the first students of the Weimar Bauhaus, where he specialised in furniture. He stayed on after graduation to teach at the Bauhaus in Dessau as head of the joinery and cabinet workshop, 1925–28, after which he set up in private practice in Berlin, and worked as an architect in partnership with Walter Gropius until 1941. He designed his Wassily chair in 1924, a modular system for storage furniture in 1925, and in 1928 his Cesa chair, a version of the cantilevered chairs pioneered by Mart Stam and Ludwig Mies van der Rohe

Top: silver Art Deco teapot by Marian Brandt
*Above: a Wassily armchair designed in tubular steel by Marcel Breuer, 1925, **and below,** a chaise-longue in aluminium, also by Breuer, but a few years later, in 1932*

Broders, Roger (1883–1953)
French poster designer
He worked extensively for the Paris-Lyon-Méditerranée (PLM) railway and later for the French State railways, his posters often depicting the destination, famously

Monte Carlo, rather than the travel theme. They also often featured stylized images of fashionable women

Bruhns, Ivan Da Silva (1881–1981)
French rug designer
He established his workshop in Aisne, France, and received his first commission in 1919 from Louis Majorelle, following his exhibition in Paris. He was fascinated by deep-wool Berber carpets, which inspired him to became one of the greatest French rug designers of the period, typically creating deeply-coloured, geometric pieces

Buthaud, René (1886–1986)
French ceramicist
Initially he trained as a silver decorator in Bordeaux, before moving to Paris to study art. After the First World War he began working in ceramics, and his wares were first exhibited in 1920. His vases might be typically either painted or crackle-glazed, but Buthaud also practised the technique of sgrafitto (carved-away decoration), becoming one of its principal exponents. His work was exhibited at the Rouard Gallery, Paris, from the late 1920s to the end of his career

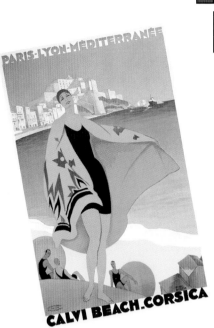

Above: a typical poster by Roger Broders from 1928 advertises the seaside resort of Calvi Beach, Corsica, for the Paris-Lyon-Méditerranée (PLM) rail service

Carder, Frederick (1863–1963)
British glass designer
Founder of the Steuben Glass Company, Corning, New York, Carder had worked for various British potteries and glass manufactories before becoming a designer for Stevens & Williams in 1881. He left England in 1903, acting as a designer for his Steuben company. There he introduced a range of glassware in French high Art Deco style in the 1920s and early 1930s, which competed with Tiffany. The company was taken over by the Corning Glassworks in 1918

Right: a trio of bronze nudes supports a two-part glass light shade. The piece was designed by the founder of the Steuben Glass company, Frederick Carder

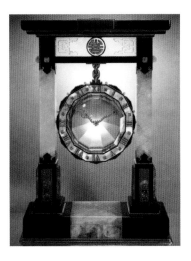

Carlton (founded in Stoke-upon-Trent, 1890)
British ceramic factory

The pottery division of Wiltshaw and Robinson, which during the 1920s and 1930s made work in geometric designs, exotically-coloured lustre art pottery, moulded tableware and small novelty items. It was one of the first manufacturers to produce oven-to-table ware

Cartier (founded in Paris, 1898)
French jewellers

During the Art Deco period the company was fond of using large, colourful gemstones in order to embellish its pieces, which were often influenced by oriental, Egyptian and Indian art. Not all materials used by Cartier were necessarily expensive, however, as some watches and clocks were designed with Bakelite cases and mounts

Cassandre, A J M (1901–68)
Ukrainian painter, poster artist, theatre designer and typographer

Born Adolphe Jean-Marie Mouron, he studied at the Académie Julien, Paris, and used the Cassandre pseudonym after 1922. During the 1930s he formed Alliance Graphique with Maurice Mayrand and exhibited in the United States, but his reputation is based on his striking travel posters and the covers designed for the magazine *Harper's Bazaar*. The best-known of these are the posters that advertised the liner *Normandie*, 1935, and the Etoile du Nord and Nord Express railway services, both designed in 1927

Catteau, Charles (1901–68)
French ceramist

Catteau joined the Boch Frères factory in 1906, and in the following year was promoted to the position of its artistic decorator. He reintroduced hand-throwing techniques to replace the lower-quality mould-produced wares that the company had concentrated on until then. Catteau, whose designs

were characteristically large, used bright enamel finishes, boldly applied in shades of blue and green. He was awarded a Grand Prix for his work at the 1925 Paris Exposition

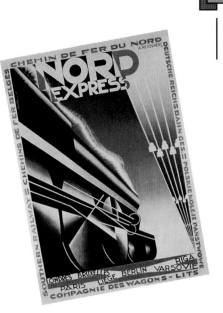

Chambellan, René Paul (1880–1966)
American architectural sculptor
Born in Hoboken, New Jersey, he studied in New York then attended the Académie Julien in Paris. He became established postwar as one of the USA's foremost architectural sculptors, contributing in New York to the American Radiator Building, 1924; Stewart & Co Building, 1928–29; foyer and façade decoration of Sloan & Robertson's Chanin Building, East 42nd Street, 1928–29; News Building, 1929–30, and the ceiling of the RKO Center Theatre in the Rockefeller Centre, 1931–40

Below: the façade of the 56-floor Chanin Building, 1928–29, was decorated by Chambellan and by Jacques Delamarre. and was a monument to the individual success of Irwin S Chanin

Below: the promotional brochure for the stepped Chanin Building, shows a detail of one of the lobby grilles by Chambellan

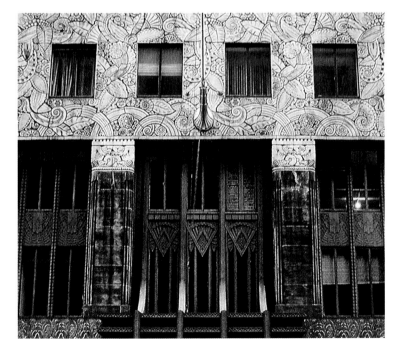

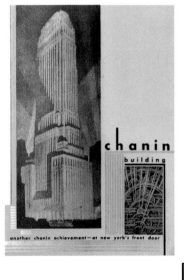

Chanin, Irwin Salmon (1891–1988)
American architect

The son of Ukranian immigrants, he built a substantial fortune from real-estate development, specialising in cost-efficient housing in Brooklyn. He established the Chanin Construction Company in the early 1920s, together with his brother. Several major commissions followed, including two of Manhattan's finest Art Deco apartment houses: Majestic Apartments, 1930, and Century Apartments, 1931. The Chanin Building in New York, decorated by Chambellan and Delamarre, also bore testament to his success

Above: the staircase leading to the sun roof and balcony of the De La Warr Pavilion, by Serge Chermayeff with Erich Mendelsohn

Chermayeff, Serge (1900–96)
Russian architect and furniture designer

Chermayev emigrated to England in 1910, where he was educated at Harrow. He was appointed director

of the Modern Art Studio in 1928, where he designed furniture and carpets. He was in practice on his own, working on interior design for the British Broadcasting Corporation (BBC) from 1931 until 1933, when he joined in partnership with Eric Mendelsohn. With Mendelsohn he designed the De La Warr Pavilion, Bexhill-on-Sea, East Sussex, 1934–35, and the Cohen House, Chelsea, London, 1936. In 1940 he emigrated to America, where he became an influential teacher

Chiparus, Demêtre (1888–1950)
Rumanian sculptor
He worked in Paris, and is best known for his chryselephantine figures in cold-painted bronze and ivory. He carved fine-quality African ivory, incorporating the grain of the material as part of the design of the figure. His ability to capture in a sensuous manner the drama and exoticism of theatre and dance, the Near and the Far East, and the quintessential female figure, are synonymous with Art Deco

Christofle (founded in 1839)
French goldsmiths and silversmiths
Charles Christofle (1805–1955) invested his entire fortune in establishing the company, which shared a stand with the Baccarat glassworks at the 1925 Paris Exposition, showing complete sets of tableware in hammered silver

Cliff, Clarice (1899–1972)
British ceramicist
Born in Staffordshire, she studied at the Burslem School of Art, and began her career as a decorator at A J Wilkinson's Royal Staffordshire Pottery. She first introduced the tableware designs in 1928, with their strong, simple, bright hues. Although some of their shapes were traditional, others sported angular stems or feet. She also introduced, for the first time to a British clientèle, ceramics that were vividly coloured in purple and what she called 'tango', which was a shade of

Below left: Les Girls, a bronze and ivory group of the 1920s, characteristic of the work of Demêtre Chiparus, the Romanian sculptor

Above: a typical hand-painted earthenware Clarice Cliff vase, of the early 1930s

Above: a decorative charger of the mid-1930s, designed by Clarice Cliff and made by Newport Pottery

Below: a Bakelite and chrome radio designed by Wells Coates for E K Cole (ECKO), of 1934. Chermayeff and Jesse Collins also produced designs for the company between 1931 and 1940

orange. Her most distinctly Art Deco work was a series of plaques entitled Age of Jazz, ceramic cut-outs which featured colourful dancing couples and formally black-tie-clad musicians

Coates, Wells (1895–1958)
Canadian architect and industrial designer
The son of a Canadian missionary, he was born in Japan and studied engineering in Vancouver before beginning work as a designer. In 1931 he won a competition to design a stand for Venesta Plywood, a British company. Together with Jack Pritchard he formed Isometric Unit Construction, which was renamed Isokon Furniture Company in 1936 when Walter Gropius was appointed controller of design. Coates designed the sound studios for the BBC in Portland Place, London, in 1931, and in 1933 helped to form the MARS group as an English chapter of the Congrès Internationaux d'Architecture Moderne (CIAM). By 1933 Coates was also designing tubular steel furniture for Practical Equipment Limited (PEL), work that was strongly influenced by Marcel Breuer's designs. When the latter arrived two years later in England, having been forced to flee Germany, he worked for a time as a consultant to Isokon, designing furniture made out of bent plywood

Colinet, Claire-Jeanne-Roberte (active 1910–40)
Belgian sculptor
Mainly known for her series of exotic female dancers, she also depicted a number of mythical and historic figures. Most of the dancers are of chryselephantine, and for these she made several versions of the same figure. Each had either a gilt or cold-painted surface, or a combination of the two

Colin, Paul (1892–1985)
French graphic artist, stage and costume designer
Although his work includes travel posters, book illustrations, theatre programme covers and posters,

and product advertisements, he is best remembered for the posters of visiting jazz musicians at the Folies-Bergères, and his 1925 series on the actress Josephine Baker at the Revue Nègre. In 1926 he opened a school for graphic arts, the École Paul Colin, where he taught for 40 years

Conway, Gordon (1894–1956)
American graphic artist and illustrator
She produced her first work for *Vanity Fair* in New York, but from 1920 until 1934 she worked in London for *The Tatler* and other magazines. Influenced by Lepape and Barbier, she used bold, contrasting colours, stylized figures and two-dimensional design elements to epitomise the jazz age

Cooper, Susie (1902–95)
British ceramist
She began work in 1922 for the A E Gray Co Pottery; like Clarice Cliff, she had first studied at the Burslem School. When she was 29 she set up her own company, and in 1931 the firm Wood & Son offered her shapes to decorate. These pieces, which were sold in London's leading department stores, were generally decorated in subdued, muted tones, though some larger pieces were brightly coloured with flower or animal motifs. Her work was exhibited at the 1925 Paris Exposition, and eventually her company was bought out by Wedgwood

Copier, Andries Dirk (1901–91)
Dutch glassmaker
He joined Leerdam Glasfabrik as an apprentice in 1917, after studying in Rotterdam and Utrecht. He produced many pieces for the 1925 Paris Exposition, where he was awarded a silver medal. He produced glass with new forms and using new techniques, to create ranges of exclusive studio glass known as Unica and Serica, which was first exhibited at Stuttgart in 1927

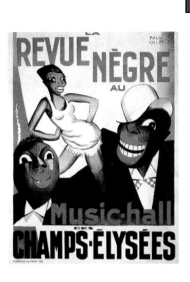

Above: this exuberant poster of 1925, depicting the American-born singer-dancer Josephine Baker with two musicians, is by Paul Colin

Below: a hand-painted 18cm (7in) high teapot of 1931, designed by Susie Cooper and produced by Wood and Sons Ltd for the Susie Cooper Pottery

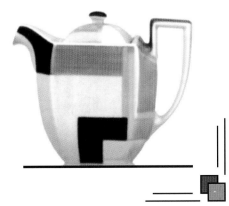

Cowan Potteries (founded in America in 1913)
Established by Reginald Guy Cowan, who created
most of its early designs, the firm quickly came to the
forefront of modern American ceramic design with
items such as decorative vases and figurines. In 1927
the company expanded to include the Cowan
Pottery Studio Inc, and in the following few years
produced some of the most impressive wares using
freelance designers such as Waylande Gregory and
Paul Manship. Its commercial success was assured
during the period by some 1,200 national outlets, and
its adoption of the latest Deco style

Cowan, Reginald Guy (1884–1957)
American ceramicist
see **Cowan Potteries**

Creuzevault, Henri (1891–1958)
French bookbinder
The designer of numerous bindings in a geometric Art
Deco style, who succeeded the binder Dodé in 1904.
He exhibited at the Musée Galliera in 1927, and again
in 1928, when he received the first prize. During the
following year he exhibited at the Société des Artistes
Décorateurs. He designed a large number of bindings
in the Art Deco style, including *La Bataille*, *Le Pot du
Noir*, and *La Rose de Bakawali*

Daum Frères (founded in Nancy, France, in 1875)
French glassworks
Founded by Jean-Louis Daum (1825–85), who began
by making gold-ornamented glass, partly based on
Arabian designs. He was joined by Jean-Antonin
Daum (1864–1930) and, during the Art Nouveau
period of 1890–1914, they produced a large number
of cameo or overlay glasses. During the 1920s and
1930s their output consisted mainly of etched glass
under the directorship of Paul Daum. At the 1925 Paris
Exposition they exhibited lamps, bowls and large
decorated vases. The colours that they used most

Left: Henri Creuzevault's
1919 binding of Rudyard
Kipling's Jungle Book *in
green morocco*

Below: a book binding
design for Les Fleurs du
mal, *written by Charles
Baudelaire, Paris, 1948, by
Creuzevault, 33 x 29 cm in
size. Although this work
was carried out somewhat
later than the period
considered as true Art
Deco, the design is very
much in the idiom, and is
composed in gold-tooled
black morocco, with
gilded edges*

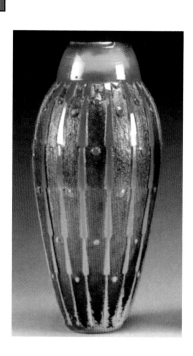

Above: a Daum acid-etched glass vase, c.1925
Below: a pâte-de-verre plaque by François-Émile Décorchemont, c.1924

during the period were smoky grey, turquoise, yellow and sea-green, although occasionally they used clear glass also. The type of decoration might be either geometric or floral, with most glass of the period being thick-walled and heavy in form

Décoration Intérior Moderne (founded in 1918)
Furniture manufacturers
Founded by René Joubert and Georges Mouveau, it manufactured the first pieces of tubular steel furniture for the mass market in France. These retained much of the austerity of the Bauhaus style of design

Décorchement, François-Émile (1880–1971)
French glassmaker
He began by working in *pâte-d'émail* (fine opaque glass paste), but in 1907 he succeeded in creating a true *pâte-de-verre*, for which he used a powdered glass obtained from the Cristalleries de Saint-Denis. He also produced near-transparent *pâte-de-cristal* vessels, by using a higher percentage of lead. Many of his thick-walled pieces were decorated with stylized plant and animal motifs, and he made great use of

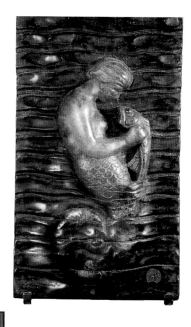

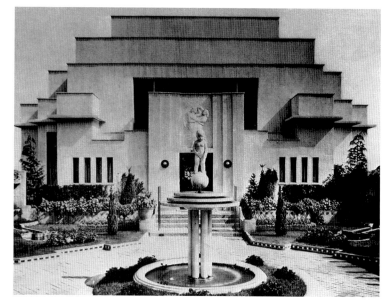

colour, producing pieces that resembled marble, tortoiseshell or semi-precious stones. This effect he produced by using metallic oxides within the glass to give a chemical streaking. He exhibited at the 1925 Paris Exposition, but from 1933 until the outbreak of the Second World War he worked primarily on special commissions that involved *pâte-de-verre* leaded glass windows for churches

Delaunay, Sonia (1885–1979)
Russian textile and fashion designer
She studied in Paris, where she married the French painter Robert Delaunay in 1910 and adapted his abstract style into her textile designs. At the 1925 Paris Exposition she displayed textiles, clothes and screens which she had designed in this style, dubbed Orphism by Apollinaire, or in America, Synchromism

Delorme, Raphael (1885–1962)
French painter
Having studied at the École des Beaux-Arts, Bordeaux, under Gustave Lauriol and Pierre-Gustave Artus, Delorme used a mixture of Art Deco and neo-classical images including *trompe l'oeil* and perspective effects. He often featured bulky, muscular female nudes wearing only incongruous headdresses or surrounded by fully-clothed maidservants, in bizarre architectural settings

Deskey, Donald (1894–1989)
American designer in the applied arts
Deskey was educated at the University of California, Berkeley, the Mark Hopkins Institute of Art (now the San Francisco Art Institute), the Art Institute of Chicago, and completed his studies in Paris, 1920–22. He was director of the art department at Juniata College, Huntington, Pennsylvania, and later the director of the industrial design department of New York University, where his work received international recognition. Advertising was his first employment, then furniture and interior design; his inventive use of industrial

Below: one of Sonia Delaunay's 1930s carpet designs, in an abstract style that is now known as Synchromism

Far left: Jacques-Émile Ruhlmann's display at the 1925 Paris Exposition was housed in L'Hôtel d'un Collectioneur, a building designed by Pierre Patout which accommodated also the work of Bernard, Bourdelle, Brandt, Decoeur, Décorchement, Jourdain, Legrain, Lenoble, Puiforçat and Rapin

materials for decorative purposes brought him a contract in 1932 from the Rockefeller Center Inc for the interior decoration and furnishings for Radio City Music Hall. He went on to produce a number of projects for various world's fairs

Right: one of the many screens to be designed by Donald Deskey for private clients during the period. All were painted with large geometric shapes with contrasting colours

Despres, Jean (1889–1980)
French jeweller
His interest in design, precious metals and jewellery only surfaced after the First World War. He made little use of gemstones in his work, preferring instead a combination of semi-precious stones and expensive metals. Much of his jewellery was painted and engraved by Etienne Cournault. He was also very

appreciative of the artistic possibilities of larger items, and made silver-plated and pewter bowls, boxes, tureens and flatware with heavily hammered surfaces

Diederich, Wilhelm Hunt (1884–1953)
Hungarian wrought-iron, ceramic and fabric designer
Hunt emigrated to the United States at the age of 15, and studied at the Pennsylvania Academy of Fine Arts. He worked in ceramics, an interest aroused when he was travelling in Morocco in the 1920s, and also in fabric design. He is best known, however, for his work in wrought iron, especially his chandeliers with animal motifs. The earthenware that he designed and made at his studio in Woodstock, New York, has a more rustic, southern-European feel to it; the characteristically thickly potted large redware dishes are glazed and decorated with earth tones. He also favoured equestrian motifs on his ceramics

Djo-Bourgeois, Édouard-Joseph (1898–1937)
French furniture designer
He studied at the École Spéciale d'Architecture, joined Le Studium-Louvre in 1923, and exhibited two ensembles in its pavilion at the 1925 Paris Exposition. He established his own business in 1926, and specialised in using modern materials in his furniture designs

Dorn, Marion (1899–1964)
American rug and textile designer
Educated at Stamford University, where she studied graphic art, she moved to Paris in 1923. Here she made textile hangings, and later rugs. Her designs gained for her the reputation as the architect of floors, with many of her pieces being sold through the London department store Fortnum and Mason. She formed her own company, Marion Dorn Ltd, in 1934 and concentrated on custom-designed and handmade rugs. She married the graphic designer Edward McKnight Kauffer in 1950.

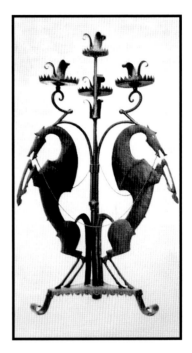

Above: this wrought-iron candelabrum of the 1920s is typical of Diederich, who frequently used silhouetted animals in his designs, especially those depicting hunt scenes

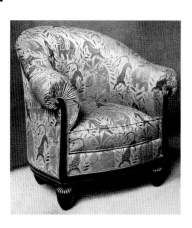

Above: this armchair was designed by Bouchet and exhibited at the 1922 Salon d'Automne, but the fabric design was by Raoul Dufy

Below: a lacquer vase of the same date, by the same designer

Dryden, Ernst (1883–1938)
Austrian graphic, costume and stage-set designer
Born Ernst Deutsch, he changed his name in 1919. He was a pupil of Gustav Klimt, and from 1926 designed covers for *Die Dame*, a Parisian fashion magazine of which he was the art director. He also designed advertising posters for a range of international companies and products, including Bugatti, Persil and Cinzano. In 1933 he moved to Hollywood, where he designed film sets and costumes

Dufrêne, Maurice (1876–1955)
French interior designer
Born in Paris, he studied at the École des Arts Décoratifs, and in 1899 began work as a designer for Julius Meier-Graefe's *La Maison Moderne*. He was a founding member of the Société des Artistes Décorateurs in 1904, and he exhibited through that organisation for the next 30 years. During that time he was appointed artistic director of La Maîtrise, Galeries Lafayette's studio, and he edited a three-volume work devoted to the interior designs shown at the 1925 Paris Exposition. His later furniture work included Modernist designs using tubular steel

Dufy, Raoul (1877–1953)
French painter, graphic artist and textile designer
Best known as a painter, Dufy also produced colourful designs for tapestry, upholstery, screens and wall hangings. From 1911 onwards, he designed fabrics for the fashion designer Paul Poiret's Atelier Martine

Dunand, Jean (1887–1942)
Swiss dinandier and lacquerer
Educated in Geneva, he moved to Paris in 1896, where he became a prolific metal worker and furniture designer who hand-produced all of his pieces. He worked in copper, steel and pewter, originally in the Art Nouveau style, gradually evolving his designs into simpler geometric stylizations. He took

up lacquer work in 1912, and later produced lacquer panels for the ocean liners *Ile de France*, *L'Atlantique* and *Normandie*. However, he was particularly interested in *dinanderie*, a technique of applying patinated enamelling over a non-precious metal such as copper or steel

Dupas, Jean (1882–1964)
French painter and poster artist
He trained at the École des Beaux-Arts, Bordeaux, and at the major Paris schools. He won the Prix de Rome in 1910, and his work includes posters and catalogue covers for the Société des Artistes Décorateurs, and porcelain decoration for Sèvres. He created series of advertisements for the American department store Saks of Fifth Avenue and London Transport, and a mural on the subject of the history of navigation for the grand salon of the ocean liner *Normandie*

Edmund Etling et Cie (active in the 1920s and 30s)
French glassmakers
Established in Paris, the company made opalescent glass figures of female nudes, animals and ships. It also exhibited at the second Salon of Light, Paris, 1934, where it showed small chromed metal and crystal lamps and illuminated *bouts de table*

Above: *typically elegant figures are used by Dupas in this 1933 advertising poster*
Below left: *the cover design for* Harper's Bazaar, *October 1927, by Erté*

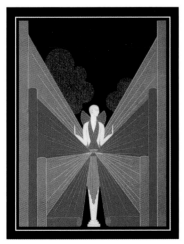

Erté (Romain de Tirtoff) (1892–1990)
Russian graphic artist, illustrator, fashion and stage designer
He moved to Paris to study architecture at the École des Beaux Arts, but instead enrolled at the Académie Julien, where he studied under the painter and stage designer Léon Bakst. He started work in 1913 as a full-time designer with the Parisian designer Paul Poiret, whom he had previously met in Russia. Strongly influenced by the French music halls and especially the success of the *Ballets Russes*, he became one of the leading graphic artists and fashion designers of his day. Along with illustrations for stories that

Right: a typical necklace, combining coral, onyx, jade and diamonds, created in 1925, by the jeweller Georges Fouquet. He had abandoned the making of more traditional pieces a few years earlier

appeared in *Cosmopolitan* magazine, he produced fashion designs for *Vogue* and covers for *Harper's Bazaar,* work for the showgirl Mara Hari, and *pochoir* prints for the fashion periodical *La Gazette du Bon Ton*

Ferrobrandt Inc (founded on Park Avenue, New York, in 1926) *see* **Brandt, Edgar**

Finmar Ltd (founded in 1934)
British furniture importers and distributors
Originally established as an outlet in the UK for furniture designed by the Finnish architect Aalvar Aalto, who first produced his stacking furniture in 1927. The company closed with the outbreak of war, in 1939

Follot, Paul (1877–1941)
French interior designer
He studied design under Eugène Grasset and designed a range of furniture that covered the entire style spectrum, from French traditional to high Art Deco. His work during the decade that followed the conclusion of the First World War was clearly based on eighteenth-century forms, with an emphasis on comfort. However, between 1923 when he accepted the directorship of the Au Bon Marché design studio Pomone and 1931, when Pomone disbanded its Paris

Below: Paul Follot designed this study for a client of the department store Au Bon Marché's studio in 1924, the intention being that the store would supply everything for the room

Right: this bookcase in lacquered wood was typical of Paul Frankl's Skyscraper style furniture from the late 1920s

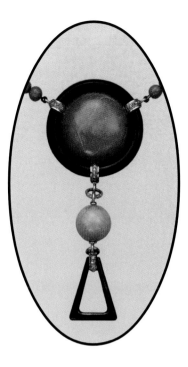

office, his style was unmistakeably pure Art Deco. All of the rooms for the Pomone pavilion at the 1925 Paris Exposition were designed with his assistants in a more progressive Modernist style than he had used before, and for the same exhibition he designed furniture for L'Ambassade Française pavilion and for L'Hôtel d'un Collectionneur. Later he prepared designs for the Primavera studio

Fouquet, Georges (1862–1957)
French jeweller
He took charge of Maison Fouquet, the superior Parisian jewellers, in 1895. In collaboration with other designers he re-directed it towards new designs, originally in the Art Nouveau style, but later on turning to the geometric shapes and variety of colour that are to be found in Art Deco in the 1920s. He played a leading part in the 1925 Paris Exposition, to which he contributed some outstanding creations with the combination of precious and semi-precious metals and stones, all influenced by oriental, Aztec and Egyptian art

Frankl, Paul Theodore (1886–1958)
Czech furniture designer
He emigrated to the United States during the First World War, where he became one of the pioneering Modernists, and was the first furniture designer there to reflect contemporary architecture. Frankl's designs typically embody geometry with an element of novelty

Gesmar, Charles (1900–28)
French poster artist and theatre designer
His posters date from 1916, shortly before he became the constant companion of the cabaret performer Mistinguett. Thereafter her performances at the Casino de Paris and Moulin Rouge were promoted by his designs for costumes, stage sets, programme covers and some 50 posters

Goldscheider (founded in 1885)
Austrian ceramics workshop
Established in Vienna by Walter and Marcell
Goldscheider, the company made figures, wall masks
and quite large earthernware sculptures. During the
Art Deco period the company produced plaster and
ceramic versions of the bronzes of the leading
contemporary Austrian sculptors

Goulden, Jean (1878–1947)
French enameller and silver designer
He studied medicine in Paris but after 1918 he learnt
enamelling from Dunand, and became involved in
the decorative arts movement in Paris. He produced
table lamps, clocks and other decorative
items, with most of his enamel designs being
executed on silver or other precious metals,
using the *champlevé* technique of cutting
into the silver and laying the enamel
in the *cloisons* or reservoirs

Goupy, Marcel (1886–1977)
French decorative arts designer
Having studied architecture, sculpture and
interior design at the École des Arts
Décoratifs, Goupy was appointed artistic
director of La Maison Georges Rouard in
1909, where he concentrated on small
enamelled glassware such as drinking
vessels, boxes, decanters and vases. He
was also responsible for some
designs for Sèvres. At the 1925 Paris
Exposition he displayed a wide
range of his work in various
pavilions, and was the vice-
president of the glass jury

Grant, Duncan (1885–1978)
British painter
see **Bell**, Vanessa

Below: a Jean Goulden
clock of 1928, in silvered
bronze and enamel

Gray, Eileen (1878–1976)
Irish architect, furniture and textile designer
She studied at the Slade School in London, where she
developed an interest in Japanese lacquer, and then
moved to Paris in 1902. There she exhibited for the first
time, at the Société des Artistes Décorateurs Salon in
1913. Jacques Doucet recognised the quality of her
work and immediately commissioned three major
pieces from her. In 1922 she opened the Jean Desert
Gallery, where she displayed some unique pieces.
She began to introduce chromed tubular steel and
aluminium into her furniture from 1925 onwards.
Significant among her works are screens, of either
geometric lacquer design, perforated metal or
perspex, and the dramatic folding 'S' chair

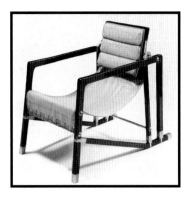

*Above: a 1926 Transat
armchair by Eileen Gray,
with black lacquer frame
and leather seat*

Gregory, Waylande DeSantis (1905–71)
American ceramicist and sculptor
He studied at the Art Institute of Kansas City and then
at the Art Institute of Chicago. Initially he worked as a
sculptor in bronze before turning to ceramics, when
he worked at the Cowan Pottery, 1929–32. He was
appointed artist-in-residence at the Cranbrook
Academy of Art and was commissioned to produce
the Fountain of the Atom and American Imports and
Exports pieces for the 1939 New York World's Fair

*Below: balconies of the
students' rooms at the rear
of the Bauhaus complex,
Dessau, by Walter Gropius,
1925–26*

Gropius, Walter (1883–1969)
German architect and designer
Born in Berlin, he studied architecture in both Munich
and Berlin, 1903–07. On graduating he gained
experience in the offices of Peter Behrens, before
establishing his own practice in 1910 with Adolf Meyer,
1881–1929. He was appointed director of the
Großherzogliche Kumstgewerbeschule Weimar
(Grand Ducal School of Applied Arts) and the
Großherzogliche Hochschule für bildende Kunst
(Grand Ducal Academy of Arts), and merged the two
schools in 1919 into the State Bauhaus. He resigned
from the position in 1928, and moved to Berlin where

Architectural movements contemporaneous with Art Deco included the Cubist-inspired Modern movement, which had unmistakeable affinities with Art Deco, in a subtle streamlined or geometric element, or a more discreet concession to ornament. The seminal buildings in Germany were designed

he became the supervising architect of the Siemensstadt estate, 1929–30. He emigrated to England in 1934, where he worked with Maxwell Fry and with Wells Coates at Isokon until emigrating to the United States in 1937. He was appointed professor of architecture at Harvard, and collaborated in various schemes with Marcel Breuer, founding the young artists' group The Architects' Collaborative (TAC) in 1946. Major works of the period include:
Bauhaus complex, Dessau, 1925–26
Torten estate, near Dessau, 1926–28
City employment office, Dessau, 1927–29
Siemansstadt estate, near Berlin, 1929–30
Sun House, Hampstead, London, 1935

*by Walter Gropius and included the Bauhaus building in Dessau and the Torten Estate housing, for which he had overall responsibility, on Dessau's outskirts. The house shown **above**, the prefabricated Steel House, 1926–27, was designed by George Muche, a master of the Bauhaus. **Below** is the recently-refurbished city employment office, also in*

Dessau, by Gropius. Originally this did not have the lower windows in the large semi-circular single-storey public hall, which had five separate offices for public enquiries, each of which had its own entrance. Behind and adjoining this public part of the building is the administration block

Groult, André (1884–1967)
French furniture designer and decorator
Created in his atelier in Paris, his pieces began to be available from about 1910; they were conspicuously constructed in sumptuous materials such as shagreen and horn. For the 1925 Paris Exposition he designed the lady's bedroom for the *L'Ambassade Française*

Hagenauer Werkstätte (founded in 1898)
Austrian sculpture workshop
Established by Carl Hagenauer (1872–1928), this studio specialised initially in ornamental pieces, metal tableware, lamps, mirrors and vases, but achieved fame for its metal figurines and groups produced and exhibited during the Deco period

Heal & Son (founded in 1810)
British furniture store

Above: in 1936 René Herbst designed this chaise longue along the same principles as his Sandows chair, with a tubular steel frame and a woven rattan seat

Between 1896 and the 1950s all of its furniture was designed by Ambrose Heal (1872–1959), whose early pieces followed the English Arts and Crafts movement's principles. During the 1920s and 1930s it preferred lighter-coloured woods such as limed oak, then weathered oak instead of unpolished woods; all pieces were hand-finished, with minimal decoration

Herbst, René (1891–1982)
French architect and furniture designer
Although originally trained as an architect, he began experimenting with metal, glass and mirror as an alternative to wood for furniture design as early as 1926. His Sandows chair of 1929 was the first metal chair to make innovative use of elasticated straps for the seat

Hoffmann, Wolfgang (1899–1989)
Austrian interior designer
The son of the great architect Josef Hoffmann (1870–1956), he studied both architecture and the decorative arts before emigrating to the United States in 1925, where he opened his own studio in 1927. He designed a wide range of interiors, collaborating with his Polish-born wife Pola; they were at the vanguard of the American Modernist movement, participating in all of the New York exhibitions during the late 1920s

Hood, Raymond Mathewson (1881–1934)
American architect
Studied architecture at the Massachusetts Institute of

Below: Raymond M Hood designed in 1933 this huge Electrical Building for the Chicago exhibition, A Century of Progress. The sculptural figure on the façade represents Energy, the substance of all things

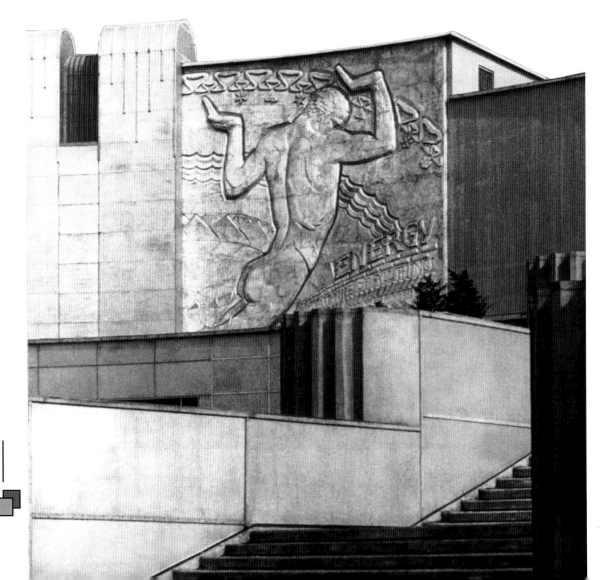

Technology, from which he graduated in 1903. He joined the New York practice of Bertram Goodhue for a brief period, before moving to Paris to study at the École des Beaux-Arts. Together with John Mead Howells (1868–1959), in 1922 he won the competition for the *Chicago Tribune* tower, which was built between 1923–25. This was followed first by his black and gold American Radiator building, 1924, then by one of his first skyscrapers, the McGraw-Hill building, 1931, designed in the International Modern style. Both these, and his Daily News building of 1930, were in New York. He used closely-set verticals for the latter, a forerunner of his Rockefeller Center, New York, 1931–34; he was also one of the architects of the centrepiece for the latter, the RCA building, of 1934

Above: Hood's Rex Cole showroom, Brooklyn, 1931, was in the then-popular stepped-back Deco style

Icart, Louis (1880–1950)
French printmaker, painter and book illustrator
First employed in Paris by a company that printed postcards, he opened his own studio in 1908 to print magazines and fashion brochures. After 1918 he concentrated on lithographs and etchings, producing literally hundreds of these in a romantic and sensuous style

Below: an early marble-topped commode in mahogany, ebony and shagreen by Paul Iribe

Iribe, Paul (1883–1935)
French designer of applied arts
Born Paul Iribarnegaray, he was trained as a poster artist and made his name drawing caricatures for the Parisian journals *L'Assiette au Beurre* and *Le Rire*. During the early 1900s he developed his skills as an interior decorator, and designed a range of jewellery, fabrics, wallpapers and furniture for Paul Poiret, among others. He undertook a commission from Jacques Doucet in 1912, to furnish his Paris apartment at 46 Avenue du Bois

Isokon (founded in 1932)
British furniture designers
see **Coates, Wells**

Jensen, Georg (1866–1935)
Danish silversmith and jeweller

He was apprenticed to a goldsmith in Copenhagen, and continued with the craft while studying drawing, engraving and modelling in his efforts to become a sculptor. He opened his workshop in Copenahgen in 1904, emerging as the leading Danish silversmith of the period, he dominated productions in northern Europe until the outbreak of the First World War. He opened further workshops in Berlin, Paris, London and New York, and produced a very wide range of pieces that included flatware, domestic ware, candlesticks, jewellery, cocktail shakers (especially for the American market) and cigarette cases. He employed many freelance designers, and collaborated with Johan Rohde (1856–1935) who was instrumental in introducing the first simple streamlined designs of the Art Deco style into the firm's repertoire, and Harald Nielsen (1892–1977) who produced simple, elegant, designs, and introduced the more modern style with his Pyramid pattern flatware service designed in 1926

Above: one of many similar candelabra that Georg Jensen produced during the 1930s
Below: Betty Joel's bedroom design with veneered curved walls, for the Royal Academy Exhibition of British Art in Industry

Joel, Betty (1896–1984)
British furniture and textile designer

Born in China, the daughter of an administrator there, she established a furniture workshop with her husband David in England in 1921. She later opened a factory in Portsmouth, and a shop in London. However, her designs did not achieve a more angular appearance until the 1930s

Kahn, Ely-Jacques (1884–1972)
Austrian architect

He was educated at Columbia University, America, and the École des Beaux-Arts, Paris, before joining an American architectural practice in 1915. By the late 1920s, Kahn was established as the leading exponent of Modernist architectural design in America, with over twenty commercial buildings of his being erected in New York between 1925 and 1931

Karasz, Ilonka (1896–1981)
Hungarian textile, ceramics and silver designer
She emigrated to the United States with her sister,
Mariska, in 1913. The latter took responsibility for the
production of Ilonka's designs, which were
characteristically abstract, floral and brightly coloured

Kauffer, Edward McKnight (1890–1954)
American graphic artist and rug designer
He spent most of his working life in Britain, designing
rugs to be integral parts of a room setting. He worked
on commercial rug designs for Wilton Royal Carpets
with Marion Dorn, whom he later married. His designs
are characteristically vivid, often containing angular
elements to provide an interplay of shape and form,
giving his rugs a three-dimentional quality

*Right: the multi-talented
Edward McKnight Kauffer
designed a multitude of
advertising posters for the
petroleum industry, in
addition to numerous
book covers, **above right***

Kéléty, Alexandre (d.1940)
Hungarian sculptor
He studied in Toulouse and Paris, and made his
reputation by modelling elegant small-scale figures of
dancers, ladies of fashion, mythological characters,
and animals. Much of his work, which included
chryselephantine figures of female subjects, was out
of the ordinary, exotic and sensuous

Kieffer, René (1875–1964)
French bookbinder
Educated at the École Robert-Estienne, Kieffer then worked for the binder Chambolle for ten years. He was a co-founder of the Société des Artistes Décorateurs, and from 1917 he executed most of Legrain's bookbinding designs for Doucet

Kiss (Kis), Paul (1885–1962)
Romanian wrought-iron designer
He collaborated with Edgar Brandt before establishing his own atelier, had his own stand at the Paris Exposition of 1925, and later worked with Paul Poiret. Among his more monumental works is a grille for the palace of the King of Siam

Above: a patinated bronze figure by Alexandre Kéléty, of the mid-1920s

Klint, Kaare (1888–1954)
Danish architect and furniture designer
In 1914 he collaborated with his tutor Carl Peterson on the design of neoclassical furniture for the art gallery at Faalborg, Denmark. He was appointed as lecturer in furniture design at the Copenhagen Academy, where he became professor of architecture in 1944

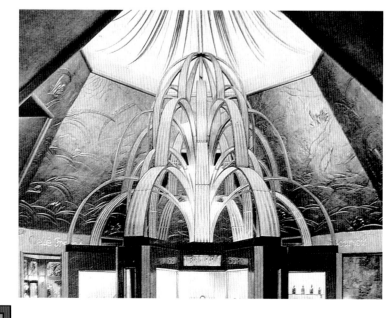

Left: this fountain-like glass sculpture surmounting the display cabinets of the Parfumerie Française display in the Grand Palais at the 1925 Paris Exposition was just one of the many contributions of René Lalique

Far right: René Lalique's stylized glass fountain that greeted the visitors at the main entrance to the 1925 Paris Exposition

Lachaise, Gaston (1882–1935)
French sculptor
Trained in Paris, he emigrated to the United States in 1906, and in 1917 married his model Isabel Dutaud Nagle, who was the inspiration for his trademark voluptuous but geometric female forms. In 1929 he designed reliefs for the RCA and International buildings at the Rockefeller Center

Lalique, René Jules (1860–1945)
French jewellery and glass designer
One of the foremost jewellers of the Art Nouveau period, his work developed so that he emerged as the leading glass designer of the Art Deco period that followed. He designed and created a wide range of objects that included car bonnet mascots, perfume bottles (especially for François Côty), highly-decorated vases, tablewares, clocks, jewellery, lighting and figurines. At the 1925 Paris Exposition not only did he have his own pavilion but also he designed and manufactured a glass table, wine glasses and candlesticks for the Sèvres pavilion. His celebrated stylized glass fountain, at the main entrance of the exhibition at La Porte d'Honneur, provided both a centrepiece for the perfume pavilion and a defining symbol of French Art Deco of the 1920s. In 1932 he supplied glass panels and chandeliers for the ocean liner *Normandie*. Most of his wares were opalescent, produced by adding phosphates, fluorine and aluminium oxide to glass in order to make it opaque, and by adding tiny amounts of cobalt to produce an internal blue tint

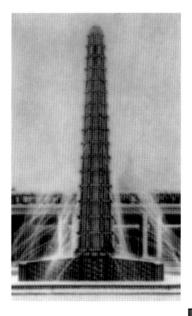

Lalique, Suzanne (1892–1989)
French ceramicist, painter and textile designer
The daughter of René, she trained as a painter before producing porcelain designs first for Sèvres and later for Théodore Haviland et Cie of Limoges. This company's own stand at the 1925 Paris Exposition included tableware decorated with her designs

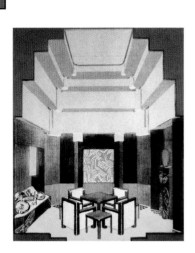

Above: the smoking room for L'Ambassade Française at the 1925 Paris Exposition was designed by Francis Jourdain, and featured black lacquer furniture by Jean Dunand. The red lacquer screen in the centre of the illustration was designed by Lambert-Ruchi and executed by the prolific Dunand

Lambert-Rucki, Jean (1888–1967)
Polish sculptor and painter
After being educated at the School of Fine Arts, Cracow, he moved to Paris in 1911, where he exhibited at the Salon des Indépendants, the Section d'Or, the Léonce Rosenberg gallery, and the Salon des Tuileries. His works, which were executed in a wide variety of materials, were influenced to a large extent by a powerful combination of African art and Cubist principles

Leach, Bernard (1887–1979)
British ceramicist
England's most prolific and prominent studio potter, Bernard Leach, was born in Hong Kong of British parents, and deeply imbued with the Oriental belief that the artist is inseparable from the craftsman. His apprenticeship was served with a traditional Japanese potter, and when he returned to England in 1920 he established the St Ives pottery in Cornwell. He opened a further studio in Devon in 1936, by which time he had attained the pre-eminent position that he retained to the end of his life

Right: Le Corbusier's classic cowhide chaise, designed in collaboration with his cousin Pierre Jeanneret (1896–1967) and Charlotte Perriand, the French furniture designer

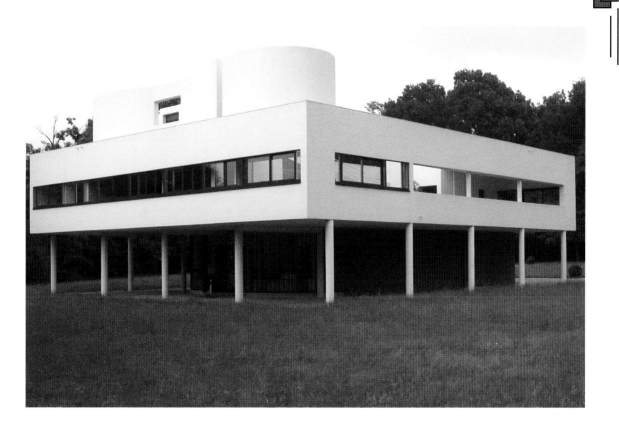

Le Corbusier (1887–1965)
Swiss architect

Charles-Édouard Jeanneret-Gris was educated at the School of Applied Arts, La-Chaux-de-Fonds, Switzerland, after which he was employed in the offices of Peter Behrens, 1910–11. When he moved to Paris in 1917, he changed his name to Le Corbusier. He published *Après le Cubisme* with the artist Amédée Ozenfant in 1918, and was appointed editor of the journal *L'Esprit Nouveau* in 1920, entering into partnership with his cousin Pierre Jeanneret in 1922. *Vers une Architecture*, a collection of his articles from *L'Esprit Nouveau*, was published in 1923. In 1928 he became a founder member of the Congrès Internationaux d'Architecture Moderne (CIAM). This organisation compiled a manifesto for a functional city in 1933, which was further developed by Le Corbusier in 1941 and published by him as *Charta of Athens* in 1944

Above: Le Corbusier's Villa Savoye, Poissy, France, 1929–31, is open to all directions. Built in concrete, it is a classic example of the International style and hovers majestically above a grass plane on thin concrete piloti. It has strip windows and a flat roof that has a deck area and a ramp. The garages, located beneath the building with the servants' quarters, were designed by the Swiss architect to fit to the turning circle of the 1930 Voisin car

Leerdam Glasfabrik (founded in 1765)
Royal Dutch glass works
The designer Chris Lebeau transformed this factory into one of the major European producers of modern glassware during the Art Deco period. Andries Dirk Copier created studio glass exclusively for it, but it also produced goblets, mass-produced tableware, and stained glass, to the designs of Henry van der Velde and Frank Lloyd Wright

Le Faguays, Pierre (1892–1935)
French sculptor
One of the most prolific sculptors of the period; his works ranged from mythological characters to allegorical representations, mostly fashioned in bronze, silvered bronze, or bronze and ivory. During the 1920s he produced work for Goldscheider, and exhibited work as part of the latter's La Stèle range at the 1925 Paris Exposition. Le Faguays' later work became hyperstylized, concentrating on figures in exaggerated poses, that had elongated outlines

Legrain, Pierre (1887–1929)
French bookbinder, furniture designer and interior decorator
Educated at the Collège Sainte-Croix, Neuilly, and the École des Arts Appliqués Germain Pilon, he assisted

Below: a console table of giltwood covered in snakeskin by Pierre Legrain, 1925. This piece was exhibited for the first time at the first Salon of the Union des Artistes Modernes, 1929

Iribe with the decoration of Jacques Doucet's Paris apartment before embarking on his book bindings in 1917. He produced some 400 binding designs for Doucet in an abstract geometrical style, to blend with the couturier's collection of Cubist paintings and sculpture. An innovative variety of materials such as mother-of-pearl and sharkskin were used to reflect collages made earlier by Picasso. Legrain established his own bindery and furniture studio in 1923

Lempicka, Tamara de (1900–80)
Polish painter
Together with her Russian husband, Thadeus Lempitzski, she fled the Russian Revolution and settled in Paris in 1918, although he abandoned her there shortly afterwards. She enrolled at the Académie Ransom, studied under Maurice Denis and André Lhote, and between 1925 and 1939 developed her highly distinctive style. This was characterised by bright colours, hard-edged and elegant angular forms in over 100 portraits and nudes, to make her the painter most representative of the Art Deco style. In 1927 she was awarded the first prize at the Exposition International des Beaux-Arts, Bordeaux

Lenci (founded Napoli, Italy, in 1919)
Italian ceramic workshops
Established by Enrico and Elena Scavini, it initially produced childrens' dolls and wooden furniture, before developing a ceramic manufactory in 1928. In addition to glazed earthenware and porcelain, it was responsible for series of mostly single-subject figures, some of which were stylish and Madonna-like, while others were of scantily-clad kitsch female figures

Lepape, Georges (1887–1971)
French illustrator, painter, poster and fashion artist
A pupil of the École des Arts Décoratifs, Paris, he went on to study at Atelier Humbert and Atelier Cormon. He illustrated *Les Choses de Paul Poiret* in 1911, and in

Below: an illustration by Georges Lepape from the pre-First World War period; this was published in 1913 in the magazine Femina

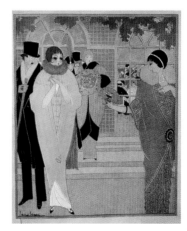

the following year programmes for *Ballets Russe*. These were followed by countless magazine covers and fashion plates for *La Gazette du Bon Ton* and *Vogue*

Lindstrand, Vicke (1904–83)
Swedish glassmaker
Lindstrand began his glassmaking career in 1928 as a designer with Orrefors where he remained until 1940, his work being widely exhibited during the period. In the 1930s he developed Ariel glass, in which the glass is manipulated to create unusual effects

Linossier, Claudius (1893–1955)
French dinandier
He was apprenticed to a metalworker at the age of 13, and shortly after the First World War opened his own small atelier in Lyon where he developed his own alloys in an attempt to achieve a richer range of tones and colours than those of silver and copper. He is now chiefly remembered for his elegant designs of vases, bowls and plates, which all had textured surfaces

Lorenzl, Josef (1892–1950)
Austrian sculptor
His work that was produced in Vienna during the Art Deco period was almost entirely based on the female figure, but in a unique style of his own. These figures were most usually small, highly stylized and created either in bronze, ivory or occasionally chryselephantine. The majority of them were either gilded or silvered, and they were mounted on tall bases, usually of green onyx. The figures were typically nudes, long-limbed and fashionably slight in their proportions; they tended to be poised on one leg, with the arms outstretched and head thrown back, the facial expression simplified

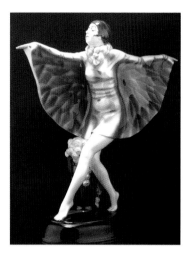

Above: a pottery figure designed by Josef Lorenzl for Goldscheider, of the mid-1930s

Luce, Jean (1895–1964)
French glass and ceramic designer
Established his own atelier in 1923, when he was using

clear enamel for decoration. He turned to sandblasting for his designs, which consisted of abstract patterns and stylized flowers, in 1924. The porcelain and glass for the liner *Normandie* were to his designs

Lurçat, Jean (1892–1966)
French painter, tapestry designer and ceramicist
Originally Lurcat had been taught by Victor Prouvé in an Art Nouveau style, and initially he worked as a painter, but later turned to tapestry. He designed a circular carpet for the *bureau-bibliothèque* at the 1925 Paris Exposition, and became instrumental in promoting the renaissance of tapestry design during the Art Deco period

Maison Boucheron (founded in Paris in 1858)
French jewellery store
Established by Frédéric Boucheron at the Palais Royale in 1893, this became the first jewellery store to serve the social élite from the Place Vendôme, where Boucheron vied with Cartier to supply the most up-to-date designs to the most chic denizens of the capital

Mallet-Stevens, Robert (1886–1945)
French architect and interior designer
Born in Paris, he took the surname of his father, Maurice Mallet, and his maternal grandfather Arthur Stevens, a Belgian. He enrolled at the École Spéciale d'Architecture in 1905 and graduated in 1910; later on, he was to return there as a professor in 1924. He established his business after the First World War, going on to design a wide range of private residences, theatres, cinemas, shops, offices and public gardens. This body of work included the six houses in Auteuil, Paris, 1926–27, which occupy the small street bearing his surname, and comprise perhaps the finest complex of French Art Deco dwellings. The whitewashed structures are basically Cubist in conception, but they are enlivened by curves, colour

Two typical Boucheron pieces of c.1925: an enamel case with a central decorative motif of a stylized vase of flowers in agate and diamonds, and a black and red Art Deco ring

Right: the Pavillon du Tourisme at the 1925 Paris Exposition was designed by Robert Mallet-Stevens; it is said to have been inspired by the designs of Antonio Sant'Elia (**below**), which depicted futuristic solutions to transport and housing. Mallet-Stevens' building was constructed in reinforced concrete, and its tower became the inspiration behind the building of the Pavilion of Tourism at the Chicago Century of Progress Exposition of 1933

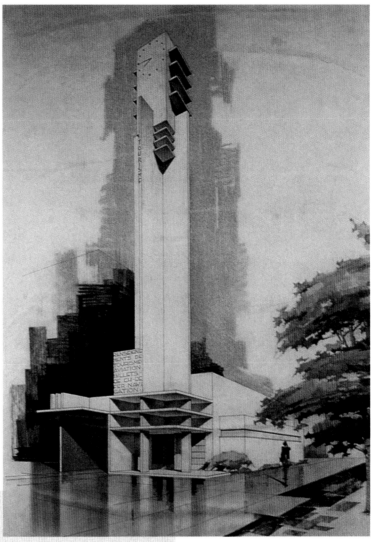

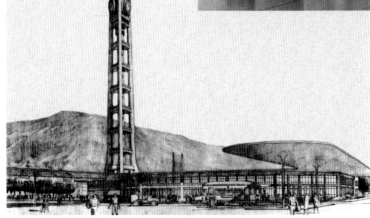

Left: a Mallet-Stevens villa design from 1923. Some of the Mallet-Stevens houses were designed in the Cubist style, with lively façades of contrasting volumes, detached areas and reliefs. **Left and right below**: rue Mallet-Stevens, Paris, widely regarded as the first examples of Art Deco architecture, 1927. **Left** is Mallet-Stevens' own house, and **right** that of the Martel twins. Its central circular staircase turret was glazed with stained glass designed by Louis Barillet. **Centre below**, the entrance hall of the Martel house. Mallet-Stevens also designed some of the furniture for these villas, as for many of his others, in plastic, metal and chrome-plated tubular steel

and decorative elements such as leaded-glass windows with geometric patterns. For the 1925 Paris Exposition he participated in no fewer than five diverse projects: a studio for La Société des Auteurs du Film; a winter garden; the pavilion for Le Syndicat d'Initiative de Paris; the Pavillon du Tourisme, and a hall for L'Ambassade Française. He was a co-founder of the Union des Artistes Modernes, of which he was appointed president in 1930

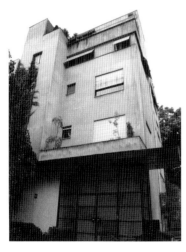

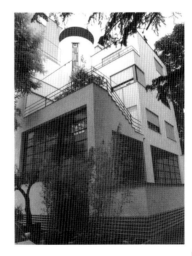

Manship, Paul Howard (1885–1966)
American sculptor
After studying at some of the major colleges in both America and Europe, he developed the style which was to influence an entire movement of American sculptors in the 1920s and 1930s. He obtained several commissions for garden sculpture from his architect friends Charles Platt and Welles Bosworth, and combined this with small-scale bronze models based on classical subjects

Mare, André (1887–1932)
French painter, and furniture and textile designer
He originally studied painting in Paris, but by 1910 his attention had turned to the decorative arts, including

Left: tapestry designed by Charles Dufresne was used by Süe et Mare to cover this suite of furniture, which still showed some echoes of the French Empire style, at the 1925 Paris Exposition

Right: some apartments on the Weißenhof estate, Stuttgart, 1927, by Ludwig Mies van der Rohe

book bindings, furniture and ensembles. Immediately prior to the outbreak of the First World War he formed an association with Louis Süe, although this was not formalised until the establishment of La Compagnie des Arts Français in 1919. The firm of Süe et Mare was one of the most successful collaborations for furniture design during the subsequent decade. The partnership immediately attracted the attention of a wealthy clientèle with sophisticates tastes, from which the company was able to prosper until 1929

Marinot, Maurice (1882–1960)
French glassmaker and painter
Born in Troyes, he moved to Paris in 1901 where he trained as a painter, but became fascinated by glass following a visit to the glassworks of Eugène and Gabriel Viard. He spurned all of the mass-production moulding techniques, preferring to make all of his pieces by hand. His earliest examples consisted of clear glass decorated with coloured enamels. Later he sculptured in glass etched in acid or shaped by the wheel, and he continued to make glass until 1937 after the closure of the Viard brothers' factory, when he returned to painting

Martel, Jan and Joël (both 1896–1966)
French sculptors and designers
These twin brothers embodied the spirit of French Art Deco, in terms equally of their novel use of the various media, the sophistication and cleverness of their design, and their constant implementation of new ideas. Their remarkable white ceramic figure of Jean Borlin, the leading dancer with the *Ballets Suédois*, adorned the smoking-room of L'Ambassade Française at the 1925 Paris Exposition. They also contributed Cubist-styled low-relief wall sculptures for Robert Mallet-Stevens' Pavillon du Tourisme at the same exhibition, and went on to provide pieces for Mallet-Stevens' ground-breaking houses in Auteuil

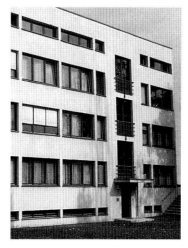

Mathsson, Bruno (1907–88)
Swedish architect and furniture designer
He is best known for his 1934 Eva chair, which had a curvilinear laminated wooden frame and webbing in the upholstery. After the Second World War he concentrated on his architecture before returning to furniture again in the late 1950s

Mies van der Rohe, Ludwig (1886–1969)
German architect and furniture designer
Born in Aachen, he moved to Berlin in 1905 where he

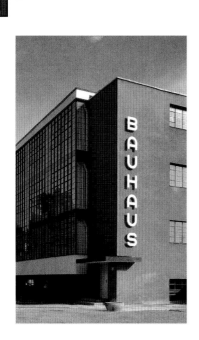

Above: the Bauhaus at Dessau, where the last director before it closed in 1932 was Mies van der Rohe

Below: a typically simply styled earthenware vase of the mid-1930s, by Keith Murray for Wedgwood

studied under Bruno Paul. Between 1908 and 1911 he worked in the offices of Peter Behrens, at the same time as both Walter Gropius and Le Corbusier. He moved to Den Haag in 1911 before returning to Berlin two years later, to establish his own practice. He became a member of the Novembergruppe in 1922, and together with van Doesburg, Lissitzky and Richter, he published the journal G (for *Gestaltung*). In 1926 he was appointed vice-president of the Werkbund, and in 1927 as director of the exhibition at Stuttgart-Weißenhof, for which he designed a block of flats. He directed the Dessau Bauhaus from 1930 until it closed in 1932, and before the outbreak of the Second World War he emigrated to the United States, where he was director of the department of architecture at the Illinois Institute of Technology, Chicago

Mouron, Adolphe *see* **Cassandre**

Müller-Munk, Peter (1904–67)
German silversmith
He studied in Berlin, but exhibited at the 1925 Paris Exposition before going to New York the following year to work for Tiffany and Co. In 1927 he opened his own studio and produced work that is characterised by simple lines and refined neoclassical designs

Murray, Keith (1892–1981)
New Zealand architect and ceramicist
Murray emigrated to Britain in 1906, and spent most of his working life in England producing distinctive ceramic wares; part-time for Wedgwood from 1933, but prior to that producing glasswares for Stevens & Williams. His pieces, which were all made to a very high standard, were characteristically of simple geometric shapes, and lacking in surface embellishment. His vases and bowls were often ribbed or fluted, and his glazes were usually matt, semi-matt or celadon satin. He also produced designs for the jeweller, Mappin and Webb

Nash, Paul (1889–1946)
British painter and designer
He trained as a painter and designer at the Slade
School of Art, London, and during the 1930s designed
ceramic tableware and textiles for such companies as
Thomas Webb and Sons, Stuart & Sons and for Clarice
Cliff. He was one of the founders of Unit One, an
avant-garde group of architects and artists, and one
of the important and talented artists who worked for
London Underground during the Art Deco period,
designing the posters that appeared on billboards
and station entrances

Nics Frères
Hungarian wrought-iron manufacturers
Very little is known of two brothers, Michel and Jules
Nics, except that they were born in Hungary and at
some point in their lives were granted French
citizenship. They opened an atelier in Paris in the early
1920s, and participated in the Salon des Artistes
Français. Apart from architectural work such as gates,
interior grilles and elevator cages, light fixtures
constituted a large proportion of their output

Orrefors (founded in 1898)
Swedish glassmakers
Best known for its Graal wares, which were developed
by the Swedish engraver Simon Gate (1883–1945),
and refined during the 1920s. These were produced
by etching the design onto the glass and then
encasing the piece in a clear outer layer, like a kind of
cameo technique. This glassware evolved during the
1930s, becoming heavier as the designs became
more stylized

Pêche, Dagobert (1887–1923)
Austrian decorative arts designer
He studied architecture at the Vienna Polytechnic
and the Vienna Academy, and matured into one of
the leading decorative artists of the early twentieth

Above: *a bowl made by Dagobert Pêche, in 1918*

Overleaf, top: *Miller & Pflueger designed the Paramount, Oakland, 1931, and also the beautiful neoclassical tile mural featured on the façade*

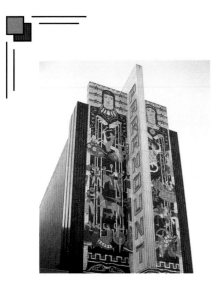

Below: a Georges Lepape fashion plate, created for Paul Poiret in 1911. It shows clearly the influence of Beardsley, while at the same time being a pointer to the imminent future and the Art Deco style. Lepape's work for Poiret brought the artist to prominence in this medium in Paris at an evolutionary period in design, equally for couture and magazine publication

century. He entered the Wiener Werkstätte in 1915, and his output of almost 3,000 designs encompassed book bindings, ceramics, furniture, glass, silver and textiles

Pflueger, Timothy L (1892–1946)
American architect
An important west-coast architect, whose projects made use of both Art Deco and Modernist elements. He was on the planning committee of the San Francisco 1939 Golden Gate International Exposition, and he was responsible for several important buildings including, *left*, the Paramount cinema, Oakland, 1931, which boasted on its façade the largest and possibly the most lavish Art Deco symbolic figures, a mosaic of two puppeteers divided by a vertical sign containing the name of the cinema

Poertzel, Otto (1876–1963)
German sculptor
One of the most prominent German sculptors at the turn of the century, Professor Otto Poertzel worked in a style very similar to that of Preiss, creating bronze and ivory figures which display a very high quality of carving. He is best known for his chryselephantine statuettes of theatrical subjects, cabaret and burlesque performers and circus acts

Poiret, Paul (1879–1944)
French couturier, painter and ensemblier
The son of a draper; at the age of 19 he joined Jacques Doucat, where he designed clothes for Rejane and Sarah Bernhardt. Later he established his own business, La Maison Poiret, and in 1912 his own workshop, Atelier Martine. The latter was used to market the designs of his pupils at the École Martine. The students' work, which included fabrics, wallpapers, murals, furniture and veneers, was used to decorate the three houseboats that Poiret displayed at the 1925 Paris Exposition

Pompon, François (1855–1933)
French animalier *sculptor*

The son of a cabinetmaker, he was apprenticed to a marble cutter in Dijon before studying architecture, etching and sculpture. In the years that followed he worked as an assistant in Paris to Mercie, Falguière, Saint-Marceaux and Rodin. With Rodin's encouragement he began to model his own figures, eventually developing the smooth, sleek look that today is regarded as the quintessential Art Deco *animalier* style

Ponti, Gio (1892–1979)
Italian architect and designer

Although he was trained as an architect in Milan, he also designed ceramics, furniture and lighting fixtures. In 1928 he established the review *Domus*, which he edited until his death. His drawings reflect the style of the Vienna Sezession, while his designs for porcelain of around 1925 appear to have been inspired by the Wiener Werkstätte

Poor, Henry Varnum (1888–1971)
American painter and ceramicist

A student of Stamford University, he was further educated in London and Paris before returning to the United States to teach in San Francisco. He concentrated on ceramics between 1922 and 1933, his inspiration coming from contemporary French paintings. He produced a mural entitled *Sports* for the Shelton Hotel, New York, and an eight-panelled tile mural, *Tennis Players and Bathers* for Edgar A Levy

Poughéon, Robert-Eugène (1886–1955)
French painter

Regarded today as one of the more successful Art Deco artists, he was taught by Charles Lameire and Jean-Paul Laurens. His early neoclassical style evolved into a highly personalised one, in which the human figure was sharply elongated

Above: a sculpture by Poertzel of the mid-1930s, in patinated bronze and carved ivory, known as The Snake Charmer

Powolny, Michael (1871–1954)
Austrian ceramicist
The founder of the Wiener Keramik in 1906, together with Berthold Löffler. The company created vases, sculptures and assorted vessels which all had the highly stylized floral and geometric designs that were so characteristic of the Wiener Werkstätte, of which Powolny had also been one of the founders

Preiss, Johann Philippe Ferdinand (1882–1943)
German sculptor
Preiss began his career in Milan before moving to Berlin in 1906, where he opened a workshop with Arthur Kassler. Two ivory carvers joined the company in 1910, thus enabling it to produce sculptures to the designs of Preiss, in a variety of media but mostly in chryselephantine. These, although small in scale, were exquisitely finished and detailed; athletic figures that were based on real sportsmen and women were the speciality

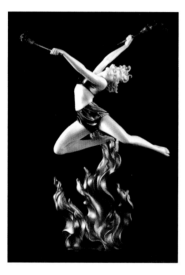

Above: a bronze and ivory figure of an acrobat. The piece, entitled Flame Leaper, *is typical of those produced by Preiss in the 1930s*

Left: another decorative piece by Preiss, also of the mid-1930s, Con Brio. It is sculpted in cold-painted bronze and carved ivory

Primavera
French design and decoration studio
One of the leading salons of the period, the studio was part of Au Printemps, the Parisian department store. It produced a wide range of ceramic wares including vases, characteristically decorated with simple stylized female forms. The atelier was directed by Mme Chauché-Guilleré during the 1920s, and it offered its clientèle everything for home decoration in the fashionable Art Deco style from complete suites of furniture to dinner plates, albeit at a significant cost

Puiforçat, Jean (1897–1945)
French silversmith

Left: a four-piece tea and coffee set in silver and rosewood by Puiforçat, of the late 1920s

Right: a table lamp in silver and mahogany, also by Puiforçat, of the mid-1920s

Puiforçat, one of the most important metalware designers in France, first exhibited his graceful designs in 1923. These were pure, unembellished forms in silver that displayed a high standard of craftsmanship. He was made chairman of both the 1925 and 1937 International Expositions. Among his many other public accolades, he became a board member of the Salon d'Automne, as well as helping to found the Union des Artistes Modernes, and being a member of the Société des Artistes Décorateurs

Rateau, Armand-Albert (1882–1938)
French furniture designer and decorator
He studied drawing and woodcarving in his home city of Paris, taking over the directorship of the Ateliers de Décoration de la Maison Alavoine in 1905. After the First World War he became an independent decorator, opening the Atelier Levallois in Neuilly, where he employed a team of skilled artisans, cabinetmakers, plasterers, sculptors, metalworkers, painters and gilders. He participated in the 1925 Paris Exposition, where he provided a range of furniture for both the Maison Callot Soeurs exhibit in the Pavillon d'Elégance, and La Renaissance de l'Art Français et des Industries de Luxe

Below: a table of the mid-1920s by Armand-Albert Ratteau; the cast-bronze mount supports a low-set black marble top

Ravilious, Eric (1903–42)
British painter, engraver and ceramics designer
He studied at the Royal College of Art, London, and later worked in watercolour, wood engraving and lithography. He produced designs for Stuart Glass and Wedgwood pottery, including the Edward VIII Coronation mug and the Oxford and Cambridge Boat Race bowl and chalice, 1938

Reeves, Ruth (1892–1966)
American textile designer
She studied at the Pratt Institute, New York and later designed wall hangings, rugs and fabrics, in a decidedly American Art Deco style. Typical of the rugs that she designed for the New York department store W & J Sloane was one called Manhattan, as well as the series which showed a heavy Cubist influence

Rietveld, Gerrit Thomas (1888–1964)
Dutch architect and furniture designer
Born in Utrecht, he began his career in his father's cabinet-making shop, continuing as a draughtsman for a jewellers. He established his own cabinet-making company in 1917, and experimented with new forms for furniture. He joined *de Stijl*, for which his Red-Blue Chair of 1918 was celebrated as a manifesto, and remained a member until it dissolved in 1931. With his Schröder House, Utrecht, 1924, Rietveld produced the only successful application of *de Stijl* principles to architecture. The house was strictly rectilinear, in white, with red, yellow, blue and black highlights, both inside and out. He was a founding member of the Congrès Internationaux d'Architecture Moderne (CIAM) in 1928, and in 1932 designed a four-family terraced house for the Werkbund Exhibition in Vienna. His other important building of the period was the Vreeburg Cinema, Utrecht, 1936

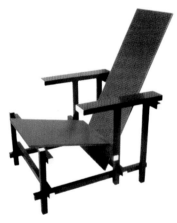

Rohde, Gilbert (1894–1944)
American furniture designer
The son of Prussian immigrants, he was first employed by Abraham and Strauss as a furniture illustrator. By the 1930s he was designing for mass production, although his designs were quality modern furnishings that were both affordable and fashionable. He worked for the Heywood-Wakefield Company, Koehler Manufacturing Company and the Herman Miller furniture company. He also produced designs for International Silver of Connecticut

Above: the Red-Blue Chair that was designed by Gerrit Rietveld according to de Stijl principles. Only black and primary colours were used, and apart from the plywood seat and back, the chair is constructed from vertical and horizontal members

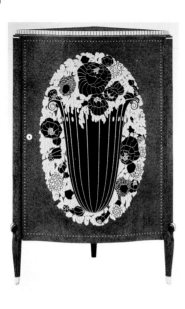

Above: *a corner cabinet made in 1916 by Jacques-Émile Ruhlmann as part of a series. This one is made in amboina wood, with an inlay of ivory and ebony*

Ruhlmann, Jacques-Émile (1879–1933)
French furniture designer
The best-known of all French furniture designers in the Art Deco style, although he was initially a painter. After the First World War, when Ruhlmann inherited his father's building firm, he added a large furniture workshop, Établissements Ruhlmann et Laurent, for which he also designed silks, carpets, textiles and lighting. His output included dining tables, chairs, beds, desks, secretaires, mirrors and upholstered armchairs. His L'Hôtel d'un Collectionneur was a major centre of attraction at the 1925 Paris Exposition. His best hand-made Art Deco pieces were produced before 1920, after which he worked in an Art Deco style based on simplified French traditional neoclassical designs, then became more Cubist in his approach; by the mid-1930s he was making extensive use of metal, tubular steel and plastics

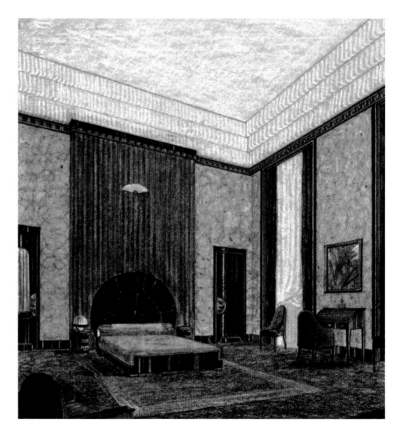

Right: *a bedroom design of the 1920s, by Jacques-Émile Ruhlmann, which shows the setting for his ebony-veneered 'sun' bed, shown on page 70*

Saarinen, Eliel (1873–1950)
Finnish architect and furniture designer

A leading exponent of the Art Deco style although his early buildings, built in collaboration with Armas Lindren (1874–1929) and Hermann Gesellius (1874–1916), were in an Arts and Crafts style. His most famous building in Finland is the railway station at Helsinki, 1905–14, built in a style inspired by the Vienna Sezession. In 1922 the Chicago Herald Tribune newspaper initiated a world-wide competition for the design of what it described as 'the world's most beautiful office building', in which he took part. Saarinen's design was placed second, and as a result he emigrated to the USA, where his great achievement was the Cranbrook Academy at Bloomfield Hills, Michigan, 1926–43. Having designed the buildings for it, he became president of the academy of art in 1932

Above: these side chairs were designed by Eliel Sarrinen for his own house at Cranbrook, 1929–30

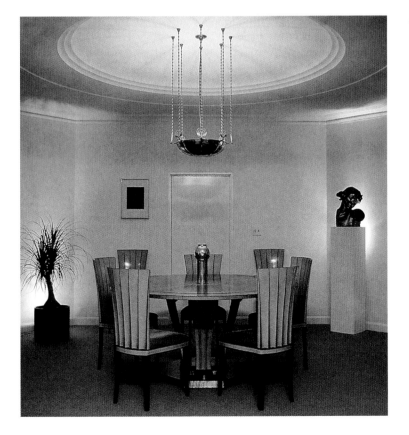

Left: the dining room in the president's house at Cranbrook included a circular table veneered in light wood, and Saarinen's side chairs, their elegant form defined by vertical fillets of black

Saarinen, Louise Gesellius (1879–1968)
Finnish textile designer
She studied in Helsinki and at the Académie Colarossi, Paris, and married the architect Eliel Saarinen in 1904. They emigrated to the United States in 1923, where she established the Loja Saarinen studio at the Cranbrook Academy in 1927. She was responsible for the design of all of the textiles that were used in the furnishing of the complex

Sabino, Marius-Ernest (1878–1961)
French glassmaker
One of Lalique's most successful competitors, Sabino first displayed a range of glass light fittings in 1925 at the Salon d'Automne; he also had his own stand in the Grand Palais at the Paris Exposition of that year. Initially he designed everything himself and produced it in his own workshops. Later on, he introduced a pressed and moulded patterned glass in bas-relief, but he is best known for his large pieces. He was commissioned to provide all of the lighting for the passageways and antechambers of the yearly Salons d'Automne, and he undertook commissions for the ocean liner *Normandie*, as well as for various hotels and restaurants

Saltø, Axel (1889–1961)
Danish ceramicist
Originally he was trained as a painter at the Copenhagen Academy of Art, then later as a draughtsman and later still as a ceramicist. He produced his best work for the Royal Copenhagen porcelain manufactory

Sandoz, Édouard Marcel (1881–1971)
Swiss animalier sculptor
Classically trained, and educated at the École des Beaux-Arts, Paris, he was responsible for the modelling of many memorials and public monuments, although he is best remembered for his large animal sculptures

Sandoz, Gérard (b.1902)
French jeweller, painter and poster artist
The nephew of Paul Follot, in 1920 he began designing jewellery which was characterised by rigorous geometric lines, and his pieces were shown in both the 1925 and 1937 Paris Expositions. He hand-made small individual geometrically-styled luxury items including pendants and brooches, which demonstrated a very restrained use of precious stones

Schoen, Eugene (1880–1957)
American architect, furniture and carpet designer
The majority of his furniture, which was small-scale and extremely elegant, characteristically involved the use of luxurious materials, including exotic woods

Serré, Georges (1859–1956)
French ceramicist
Initially employed by Sèvres as a colourist, he opened his own studio in 1922. There he produced massive vessels, incised with simple geometric motifs and glazed to resemble cut stone. During the 1940s he was in charge of the École des Arts Appliqués

Sèvres (founded in 1738)
French national porcelain manufactory
At the 1925 Paris Exposition the company showed a wide variety of porcelain and stoneware in its faience-clad pavilion. Henri Rapin (1873–1939) was both one of the company's leading designers and its artistic director, a position which he also held at the École des Arts Décoratifs from 1924. He created furniture inlaid with Sèvres tiles, and an illuminated bronze and porcelain fountain for the Salon des Lumières. During the 1920s the manufactory, which had always been subsidised by the State, commissioned designs from a wide variety of artists. Most of its wares of the time were either decorated with ornament in the Art Deco style, or painted with designs in the diluted Cubist style of the École de Paris

Far left: a brooch by Gérard Sandoz, designed in platinum, coral, jade and diamonds, of the late 1930s

Below: a beautiful plain Sèvres lamp, designed by Jacques-Émile Ruhlmann for the first-class salon of the ocean liner Ile de France in 1927, crafted in porcelain and silvered bronze

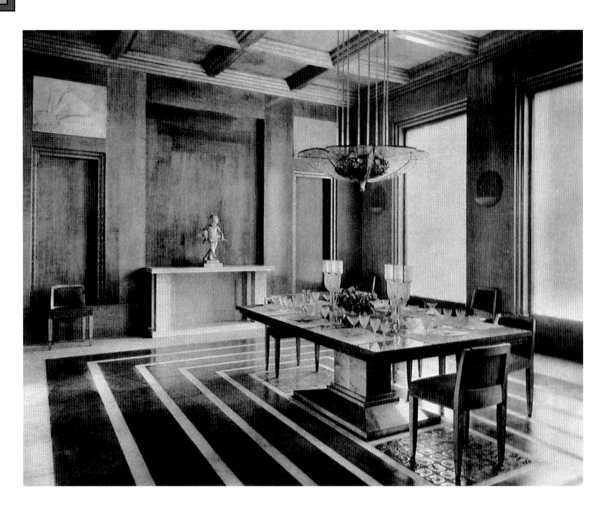

The Pavillon de Sèvres at the 1925 Paris Exposition was designed by Pierre Patout and André Ventre, and featured the room **above***, designed by Marc Ducluzeau but decorated by René Lalique. It had a glass coffered ceiling and glass floor tiles*

Shelley (founded in 1872)
British ceramics manufactory
Originally called Wileman & Co, the company changed names in 1925. Until the outbreak of the Second World War it produced a large number of tea and dinner services with designs, which were often geometric, hand-painted in enamels. Their designer Eric Slater introduced the Vogue and Mode ranges in 1930

Soudbinine, Séraphin (1870–1944)
Russian ceramicist
On moving to Paris he became a protégé of Rodin, and progressed to producing sculptural ceramics in stoneware and porcelain

Stam, Mart (1899–1986)
Dutch furniture designer
Stam began working as an architectural draughtsman in Rotterdam, but is best known for his cantilevered tubular-metal chair, designed in 1926. In the same year he was invited by Ludwig Mies van der Rohe to design three houses for the Deutscher Werkbund's 1927 Stuttgart exhibition

Steuben Glass Works (founded in 1903)
American glass manufactory
Established by Frederick Carder, the company became a division of Corning in 1918, and during the Art Deco period its work was regarded as the epitome of elegance. From 1933 the company only produced items of colourless pure crystal, most of which was in the form of large pieces with engraved designs. At the time, its main designers were Sidney Waugh (1904–63) and Walter Dorwin Teague

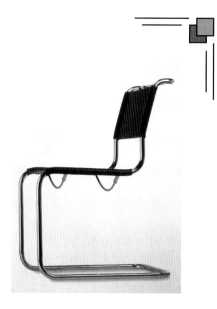

Above: this cantilevered chair of 1926 was one of the few furniture pieces designed by Stam, the Dutch architect

Storrs, John Henry Bradley (1885–1956)
American sculptor
Although born in Chicago, he lived in France and studied in Paris under Rodin. He worked in a variety of new materials and in a variety of styles, including Art Deco. He returned to the United States frequently and received major architectural commissions, including the aluminium figure of Ceres (the Roman goddess of grain, which is one of the main commodities traded in the building) that adorns the top of the Chicago Board of Trade Building, West Jackson Boulevard, Chicago, 1930, by Holabird & Root

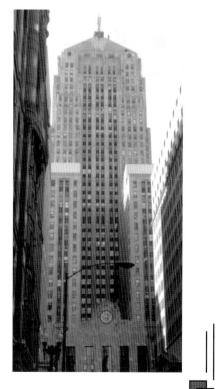

Right: the Chicago Board of Trade building, seen here as viewed down LaSalle Street, is a 45-storey Art Deco skyscraper built in limestone. Undeniably it is one of the city's finest, and for a quarter of a century it was the tallest building in Chicago. It culminates in a pyramidal metal roof surmounted by John Storr's 9.75m (32ft) sculpture of Ceres

Subes, Raymond (1893–1970)
French wrought-iron designer
Appointed artistic director of Borderel et Robert in 1919, he became one of the most important wrought-iron designers and producers of his time, working closely with established architects. He also excelled in the use of wrought iron for furniture design, taking inspiration from both the tradionalist and modern tendencies. One of his pieces, a metal bookcase, was exhibited in Ruhlmann's L'Hôtel d'un Collectionneur at the 1925 Paris Exposition

Süe, Louis (1875–1968)
French architect and designer
Initially trained as a painter, but in 1912 he opened his decorating business, Atelier Français, designing textiles, furniture and ceramics. He founded Compagnie des Arts Français in 1919 with André Mare (1887–1932), and at the 1925 Paris Exposition their work was highly acclaimed; indeed, the exposition eclipsed all of Süe et Mare's earlier work. Un Musée d'Art Contemporain their pavilion on the Esplanade des Invalides, received almost as much attention as Ruhlmann's nearby L'Hôtel d'un Collectionneur. Comprising a rotunda and a gallery, the interior was decorated by a comprehensive team of collaborators, including sculptors, carpet and textile designers and painters. Much of the furniture was in carved giltwood, upholstered in Aubusson tapestry. The firm also exhibited its work in the Parfums d'Orsay boutique; L'Ambassade Françês; the Salle des Fetês; the Pleyel stand, where it exhibited a harpsicord; the Christofle-Baccarat stand; and in the Fontaine & Cie pavilion a few silver ornaments, various furnishings and key plates. In 1928 the designer Jacques Adnet took over the directorship of the company from Süe, who then concentrated on architecture and interior design. Süe designed much of the interior decoration of the pavilion of the Société des Artistes Décorateurs for the 1937 Paris Exposition

Above: a Süe et Mare cupboard, very typical of the company's work of the mid-1920s

Teague, Walter Dorwin (1883–1960)
American industrial designer
Teague opened his own office in 1911 specialising in book and advertising designs, and following his successful packaging designs, established himself as an industrial designer in 1920. He worked for Eastman Kodak for a period of 30 years beginning in 1927, designing one of his most successful products, the plastic Baby Brownie camera, in 1933. He also worked for the New Haven Railroad company and Texaco petrol stations for which he designed the Type C gas station in the 1930s. Five hundred of these were built, each to an identical ground plan and colour scheme. The Marmon car designed in 1930 became another resounding success, and for the 1939 World's Fair he created the Ford motor company's exhibition, including the aluminium and Lucite furniture

Below: the extraordinarily popular Baby Brownie was designed by Walter Dorwin Teague for Kodak. The box was formed in black Bakelite, the pop-up viewfinder in aluminium. The camera appeared in 1934, and retailed for the princely sum of a single dollar to sell by the millions. The use of plastic made it possible to produce the camera very cheaply, in addition to its being tough and easily moulded

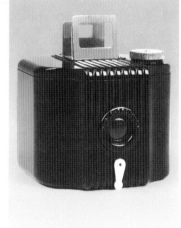

Templier, Raymond (1891–1968)
French jeweller
He joined the family firm of Maison Templier in 1919, and collaborated, for a period of 30 years with the designer Michel Percheron making jewellery, which included brooches, pins, bangles, pendants and earrings, for the luxury market. He was a founding member of the Union des Artistes Modernes

Above left: among other work, Teague designed a wide range of radios for Spartan in wood, metal, glass and plastic; many sported their streamlining purely for effect, rather than function

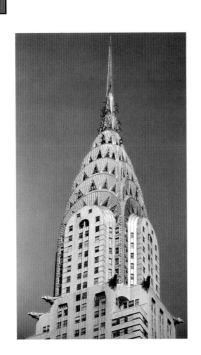

Above: a glittering jewel on Manhattan's skyline, the Chrysler Building, is William Van Alen's Art Deco masterpiece

Below: an Egyptian-Revival Art Deco diamond and multicoloured gem brooch of 1924 with a central yellow sapphire, by Van Cleef & Arpels

Van Alen, William (1883–1954)
American architect

The Chrysler Building, New York, 1928–29, provides a characteristic example of late-1920s commercial architecture that has become a classic Art Deco icon. Its height, at 77 storeys, has long been surpassed, but not its sparkling beauty; this combination of folly, fantasy, advertising motif and functional office tower most famously supplies Van Alen's memorial. Its fifty-ninth floor chromium nickel-steel eagle gargoyles and stainless steel-arched triangular-window spire took architectural playful exuberance to new heights

Van Cleef & Arpels (founded in Paris, 1904)
French jewellers

Begun by Julien, Louis and Charles Arpels and Alfred van Cleef in a small shop in Place Vendôme; they quickly established a very high reputation as master jewellers, winning a Grand Prix for jewellery design at the 1925 Paris Exposition. They introduced the revolutionary *serti mystérieux* (invisible setting) during the 1930s

Venini, Paulo (1895–1959)
Italian glass designer

Venini studied law at Milan University before changing direction and turning to glass design. In 1921 he became a partner with Cappellin in Murano, and two years later took over complete control of the company. Although he employed the foremost designers of the period, Venini himself was regarded as one of the finest

Walter, Alméric (1859–1942)
French ceramicist and glassmaker

Employed by the Daum brothers in Nancy before establishing his own glass workshops in 1919, he worked in collaboration with the painter Henri Bergé. Walter's pieces included *pâte-de-verre* medallions, wall sconces and decorative panels, but mostly he produced ashtrays, pin trays, brooches and pendants

Weber, Karl Emmanual Martin (1889–1963)
German industrial designer

He studied under Bruno Paul and was apprenticed to Eduard Schultz, Potsdam's royal cabinet-maker. He moved to the United States and worked in the design studio of Baker Bros in Los Angeles. In 1927 he opened his own industrial design studio in Hollywood, and came to be regarded as a champion of the modern movement in the United States

Wedgwood, Josiah & Sons (founded in 1759)
British pottery

The most significant contribution to Wedgwood Art Deco design was the work of John Skeaping, who was employed by the company from 1926. He specialised in animal designs, which were usually produced first in basalt, and then in a variety of colours and glazes. Apart from Skeaping's work, Wedgwood produced both traditional and *avant-garde* designs, including a range of lustre wares with images of pixies and goblins, not notably a characteristic Art Deco subject area

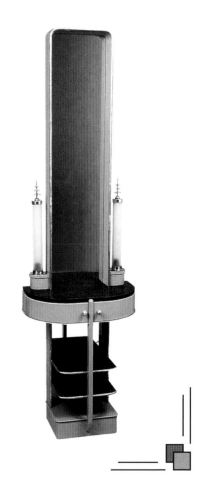

*Previous page: two pieces designed by Kem Weber; **top**, a digital clock in brass and copper, designed in 1933 for Lawson Time Inc. and, **below**, a side table which was designed for Mr and Mrs Bissinger, made in a complex assortment of materials that included burl walnut, glass, silvered and painted wood, maple, cedar, and chromium-plated metal*

Wieselthier, Valerie (1895–1945)
Austrian ceramicist

Under the influence of Josef Hoffmann at the Viennese Kunstgewerbeschule and the Wiener Werkstätte she developed a colourful and carefree style which came to fruition at the 1925 Paris Exposition. She moved to the United States in 1929, where she joined the Contempora group, before moving on to the Sebring Pottery in Ohio

Wright, Frank Lloyd (1867–1959)
American architect and designer

One of the most famous architect-designers of the twentieth century, he worked in a range of media, designing copper urns and decorative metalwares, table lamps, textiles, furniture and ceramics. He was the foremost exponent of the Prairie School of domestic architecture which was a transformation of the English Arts and Crafts philosophy into something distinctly American. His Hollyhock House, Los Angeles, 1920, is regarded as the prototype of Californian Art Deco; although Wright remained intellectually aloof

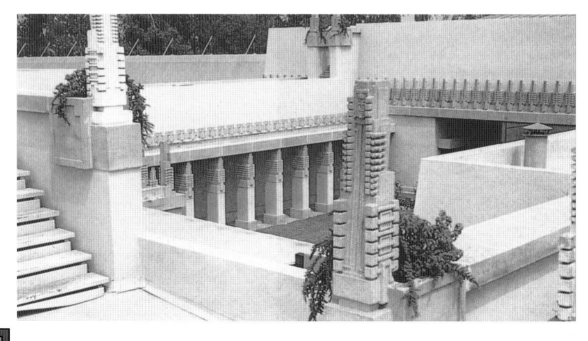

from what became known as pure Art Deco, he shared its roots in Vienna, and he was living proof that America did have a tradition of modern decoration prior to 1925

Wright, Russel (1904–76)
American ceramics, furniture and pewter designer
Wright designed his first spun-pewter accessories in 1931, and in 1935 he extended his Modern Living range of low-priced, mass-produced furniture to include co-ordinated textiles, lamps and rugs. His furniture was constructed in maple; many of the pieces were multi-functional, and therefore ideally suited to smaller rooms. His American Modern ceramic range was produced in a number of colours, in a mix-and-match sales pitch that made the range the best-selling line of ceramic ware ever

Zach, Bruno (1891–1935)
Austrian sculptor
Famous for his erotic portraits of the Berlin *demi-monde*, he worked mostly in bronze, ivory and chryselephantine, the expensive and highly desirable combination of bronze and ivory, also favouring gilt patination. He was one of the most distinctive of the artists working in Vienna at the time, and his figures were frequently translated by Goldscheider into mould-produced porcelain, which was then retailed at a fraction of the price of the original

Zorach, William (1887–1966)
Russian sculptor and painter
He moved to the United States in 1894, and worked as an apprentice lithographer while attending evening classes at the Cleveland School of Art. He lived in New York and in Paris, exhibiting paintings in both cities, but by 1922 he had foresaken painting for sculpture. He then became one of the leaders in the revival of direct carving, both in various woods and in stone, in the United States

Far left: Frank Lloyd Wright was, without doubt, the greatest twentieth-century American architect. His oeuvre spanned more than 60 years, and was never repetitive, routine or derivative. This body of work encompassed a truly remarkable series of houses in California, including the Hollyhock House in Los Angeles of 1920. Sited near the top of Olive Hill, it is constructed of exposed concrete, and consists of a main block built around a central courtyard and extended to include wings, long garden walls and terraces. The whole is embellished with many repeated motifs, clearly seen here as the finial in the foreground

NORMANDIE

THE SHIPPING LINES AFFORDED the foremost interior designers an excellent international stage on which to display their talents, like a vast extension of the annual Salon, and a number of luxury ocean-going vessels were launched during the years between the two world wars.

The design of the *Paris*, launched in 1921, was controlled by the Société de l'Art Français Moderne, which sub-contracted the work to such artists as Lalique, Follot, Dufrène and Süe et Mare.

The vessels that followed included the *Ile de France*, *La Fayette*, *Le Champlain* and *Le Colombie*, all of which served North American ports. *L'Atlantique*, unfortunately gutted by fire within fifteen months of her launch in 1931, served the South American ports together with her sister-ships *Massilia* and *Lutetia*.

These magnificent vessels culminated with the most luxurious liner ever conceived, the *Normandie*. Adorned by major decorative works, she embodied the zenith and final grace-notes of the style by such Art Deco masters such as Dunand, Dupas, Ruhlmann, Süe and Lalique. The liner arrived for the last time in New York on 28 August 1939; war was to prevent her return to Europe, and sadly she was accidentally destroyed by fire in 1942. With her demise, the Art Deco years were ended.

The liner Normandie *was launched in May 1935, and is regarded by many as a floating vision or* pièce de resistance, *the very epitome of Art Deco style. The vessel's main lounge,* **left***, was decorated with murals of etched and painted glass by Jean Dupas.* **Overleaf** *is the first-class dining room with, in the centre of the picture, a gilt-bronze figure by Louis Dejean entitled* La Paix. *This looked out across 200 dining tables that seated 700 guests; in this same hall, the lighting was by René Lalique. There were twelve fountains of light set upon pedestals, and the side walls were veneered in panels of hammered glass*

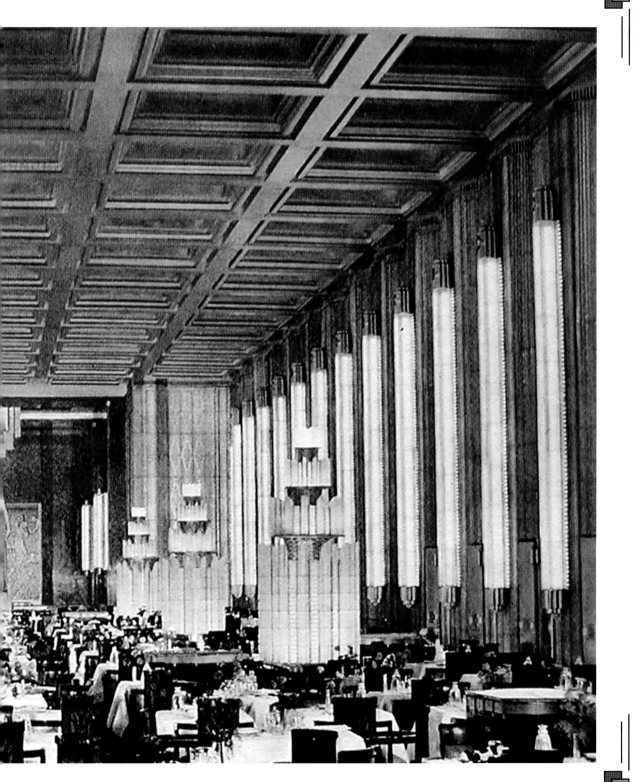

INDEX

*Pages 156–157: a
detail of the Chrysler
Building, New York,
by William Van Alen*

*Pages 158–159:
the glass-panelled
entrance to the
Strand Palace Hotel,
London, designed
by Oliver Bernard*

*This page: an Air King
radio, designed by
Harold van Doren,
the milestone in
radio design of 1933.
Its stepped-skyscraper
monumental form,
then the largest
plastic moulding in
America, made in
Plaskon, featuried a
'waterfall' façade*